GOLD BOXES

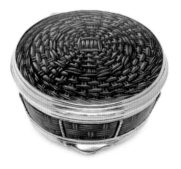

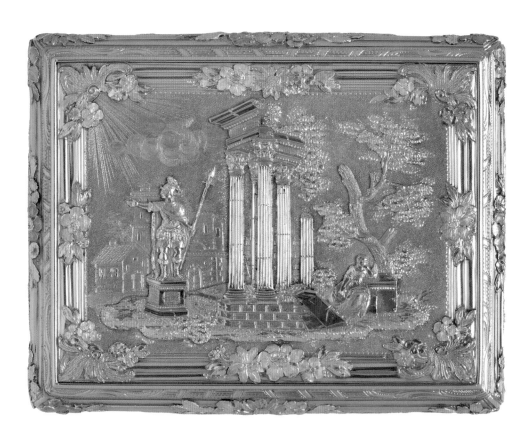

GOLD BOXES

MASTERPIECES FROM THE ROSALINDE AND ARTHUR GILBERT COLLECTION

HEIKE ZECH

PHOTOGRAPHY BY PAUL GARDNER

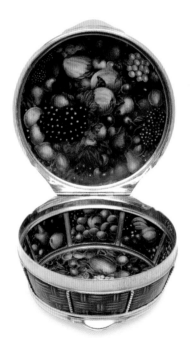

V&A PUBLISHING

First published by V&A Publishing, 2015
V&A Publishing
Victoria and Albert Museum
South Kensington
London SW7 2RL
www.vandapublishing.com

Distributed in North America by Abrams,
an imprint of ABRAMS

ISBN: 978 1 85177 840 9

Library of Congress Control Number 2015935446

10 9 8 7 6 5 4 3 2 1
2019 2018 2017 2016 2015

A catalogue record for this book is available from the
British Library.

New V&A photography by Paul Gardner

The main illustration of each box is reproduced
at actual size

Front cover illustration: no.40
Back cover illustration: no.25
Half-title page: no.44
Opposite title page: no.30
Title page: no.44

Copy-editor: Rachel Malig
Designer: Nigel Soper
Indexer: Sue Farr
Project manager: Geoff Barlow
Originated by DL Imaging Ltd
Printed and bound in Italy by Printer Trento srl

V&A Publishing

Supporting the world's leading
museum of art and design,
the Victoria and Albert
Museum, London

CONTENTS

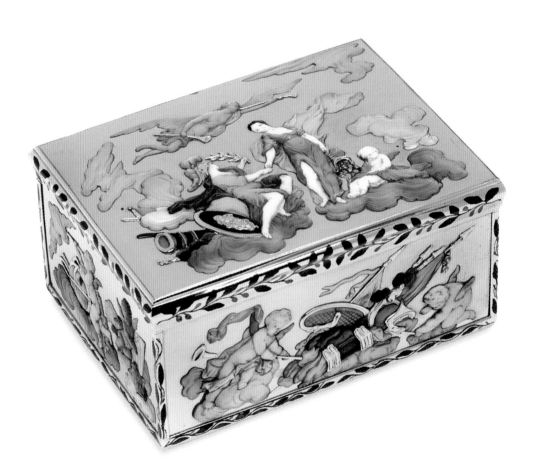

'Not for us, but for everyone' was the collecting motto of Rosalinde and Arthur Gilbert. Their tenacity and philanthropy have been the driving force behind the Gilbert Collection as a treasure for the public; as Chairman of the Gilbert Trust for the Arts since 2008, I have had the privilege to witness its transformation at its new home, the Victoria and Albert Museum, London. This beautiful volume is the first to bring gold boxes that were such a source of wonder and admiration for the Gilberts to a wider audience, and I am delighted that it coincides with a tour of these masterpieces and with the opening of the V&A's new Europe 1600–1800 Galleries. I would like to particularly thank Charles Truman, whose masterful scholarly catalogue of the gold boxes in the Gilbert Collection remains an invaluable resource.

<div align="right">SIR PAUL RUDDOCK</div>

INTRODUCTION

A<small>LL THINGS SMALL</small> hold a particular fascination and natural attraction, even more so when the minuscule dimensions are paired with precious materials and extraordinary craftsmanship. Such treasures need no excuse, no everyday purpose to justify their existence. Yet most of the boxes brought together in this volume had a clear function: they were used for powdered tobacco, also known as snuff.

Gold is the defining material of the masterpieces presented here, but it is the intricate, richly worked decoration in a variety of other materials that is the most surprising aspect for those first encountering such pieces: from porcelain to precious stones, enamel and mother-of-pearl.

The uniqueness of all the boxes on the following pages stems from their owners' desire to express not only their status in society, but also their personal beliefs and tastes. The eighteenth century was, at least for those at the top of the social scale, an age of individuality as much as conformity: Europe had rarely offered such a lavish stage for its élite. The period was at once zenith and epilogue of courtly elegance before the French Revolution, with Paris as epicentre of the production of refined, precious trinkets then known in England as 'toys'. Numerous specialized workshops collaborated with so-called *marchand-merciers*, luxury retailers who used their extensive and global networks to supply the most stunning masterpieces to their discerning clientele.

The designs for gold boxes in Paris came from some of the most creative and innovative minds of the period, including Juste-Aurèle Meissonier and Jean Mondon (fig. 1). The rest of Europe by and large emulated Parisian style; only the most eminent makers elsewhere – in Dresden, Berlin or St Petersburg – developed their own distinct range of materials and forms.

Fig.1:
Design for the lid of a snuffbox
Paris, France, *c.*1725–30
Jean Mondon
Pen, ink, watercolour and wash; the
different colours indicate different
alloys of gold, while the central
cartouche would probably have been
executed in enamel

Snuffboxes: 'toys' for tobacco

In France, boxes for snuff became known as *tabatières*, a word derived from the French *tabac* (tobacco). Tobacco had first come to Europe from the New World in the late sixteenth century. Settlements such as New Amsterdam (fig. 2), today New York, were important ports for ships taking tobacco across the Atlantic. This was just one among many substances first introduced to Europe at this time, and which are nowadays used globally, and expanding trade networks ensured that tea, coffee and chocolate all became fashionable commodities.

Originally praised for its medicinal properties, tobacco soon became a recreational drug and smoking a widespread pastime. Among the beliefs about tobacco noted by doctors and encyclopaedists such as Denis Diderot and Johann Heinrich Zedler, were that it helped to preserve sight and smell if used in moderation, especially when mixed with 'fragrant oils and flowers or their essences'. Not everyone agreed: King James I of England and King Louis XIV of France thought tobacco noxious.

Fig. 2:
View of New Amsterdam, depicting a woman with tulips and a man standing next to a barrel of tobacco leaves
Plate from *Costumes of Various Countries*, Johannes de Ram, Amsterdam, *c.*1680

Zedler's *Universal-Lexicon* (1731–54) reports different snuff preferences across Europe: 'Snuff, *Pulvis tabaci*, *Tabac en poudre*, is a powder of ground tobacco, either as very fine powder which the Spanish use, or granulated as preferred by the Italians'. Snuff could have additional ingredients and there were endless varieties with names determined by geography, such as 'Spagniol', or 'Spanish', from Seville; or by production method, such as 'Irish High Toast', where the leaves were cured by fire. Some of these varieties are still produced today.

Snuffboxes could be filled at shops such as 'At the Sign of the Civet Cat' in Paris, mentioned by Casanova; this establishment took its name from the cat that produces musk used in perfumery. The popularity of tobacco from the Civet Cat is testimony to the success of scented snuff. One of the most famous London tobacconists was 'Fribourg & Treyer' in Haymarket, which remained active until the 1980s. Larger amounts of tobacco were sold

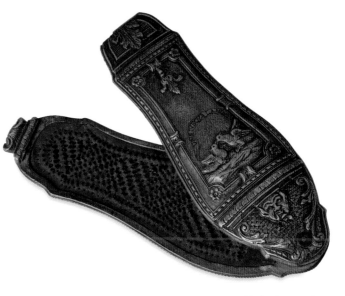

Fig. 3:
**Snuff rasp, inscribed
'UNIS JUSQU'A LA MORTE'
(Together until death)**
France, *c.*1725
Boxwood and metal

Fig. 4:
**Tobacco box set with a portrait
cameo of Charles I of England**
London, *c.*1670–85
Gold

in cones reminiscent of the shape of carrots, which could then be stored. Bespoke rasps (fig. 3) were used to grate the tobacco.

Boxes specifically for tobacco came into fashion during the second half of the seventeenth century; the Gilbert Collection includes a rare example of an English late seventeenth-century tobacco box (fig. 4) with a portrait of Charles I, venerated as a saint after the Restoration of the monarchy in 1660. The rise of snuff-taking at the expense of pipe-smoking meant bespoke containers for snuff also emerged. These boxes were pocket-sized and had a tight-fitting lid to prevent the snuff from drying out. The rise of snuff encouraged the development of pockets in skirts and coats to hold these boxes, and because snuff-takers often sneezed, handkerchiefs also became crucial accessories for snuff-taking (fig. 5).

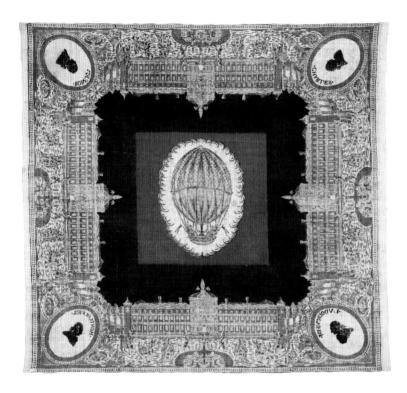

Fig. 5:
Handkerchief commemorating the first ascent of a hydrogen-filled hot air balloon at the Tuileries Palace in December 1783
Alsace, France, *c.*1783
Block-printed cotton

The sculptural Meissen porcelain group known as *The Merchant's Wife* (figs 6–7) depicts the wife doing the household accounts. In her hand she holds an open golden snuffbox. In a moment she will take a pinch, just as many women since the late sixteenth century would have done: Catherine de' Medici is famously credited to have introduced tobacco as snuff to the French court. In the 1715 *Frauenzimmer-Lexicon* (*Woman's Lexicon*), the snuffbox features among other female accessories; women, such as Queen Sophia Dorothea of Prussia, were among the earliest collectors of snuffboxes.

Patrons: precious souvenirs

The *Woman's Lexicon* lists the most common materials used for snuffboxes as 'silver, ivory, steel, horn or exotic wood'. And, indeed, several versions of *The Merchant's Wife* group represent boxes in finishes other than gold. Yet gold was always considered the superior and most exclusive material. As the character of the Count in Carlo Goldoni's 1765 comedy *The Fan* remarked, 'A gold snuffbox – that gives an aristocratic well-to-do air.'

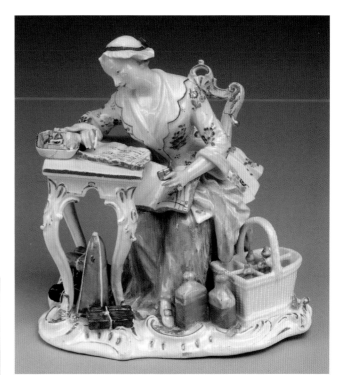

Fig. 6:
The Merchant's Wife
Germany
Probably modelled by Johann
Joachim Kändler, *c.1758*; made by
Meissen porcelain factory, *c.1758–65*
Hard-paste porcelain painted in
enamels and gilded

Fig. 7:
Detail of Fig. 6

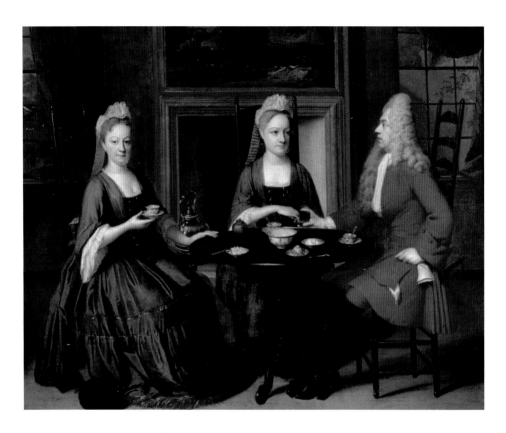

The fascination with gold snuffboxes first arose at court and is closely linked to court rituals. Snuff helped courtiers through long days in cold palaces, and, like fans and other fashion accessories, snuffboxes offered welcome points for discussion while avoiding potentially difficult topics. Soon, handling the boxes and offering snuff evolved into a secret code which, though never written down comprehensively, had a particular name: the

Fig. 8:
Two ladies and an officer seated at tea
Oil/canvas,
English school, *c.*1715

Fig. 9:
**Boîte à portrait; enamel
miniature on gold of
an Elector**
Probably Düsseldorf, Germany,
c.1690–95
J. M. Khaetscher
Silver-gilt frame with
rose-diamonds and enamel

'language of the *tabatière*'. This 'language' must have known many dialects and variations. Carl Alexander von Lothringen recorded some of its features in his diary while at court in Brussels. For example, taking snuff then pretending to flick traces of it from his coat or fur tippet was his way of asking his beloved whether she would attend a ball.

Though possibly less elaborate, the use of snuff as a means of wordless yet tangible communication is apparent in the painting *Two ladies and an officer seated at tea* (fig. 8). The gesture of the lady in the centre of the group, who reaches for a pinch of snuff from the snuffbox offered to her by the officer, adds to the tension created by the intense eye contact between them, and the scene has accordingly been interpreted as her acceptance of his marriage proposal.

Courts were also the environment in which another function for precious snuffboxes first emerged, as a token of appreciation and payment in kind when outright financial compensation was considered inappropriate. Frederick William, King of Prussia and father of Frederick the Great, gave a snuffbox to his oldest daughter Wilhelmine on his deathbed in 1740 as a 'souvenir'. It is likely that this box would have shown the King's portrait, since in the 1730s, according to Wilhelmine's diary, the King also presented her husband with 'a golden box, set with diamonds which had his portrait and was worth four-thousand *thaler*', an amount that exceeds the price of a town house in Prussia's residence town of Potsdam at the time. Such boxes had developed from so-called *boîtes à portrait*, jewelled portraits surrounded by diamonds (fig. 9), a gift of honour introduced by Louis XIV of France in the seventeenth century. Even if the recipient chose to sell the diamonds, a not uncommon decision, the *boîte* remained as souvenir.

In a society where marriage was a matter of politics not love, gold boxes became a way of lending intimacy to decisions made principally with dynastic considerations in mind. The earliest box in this volume (no. 1) is a beautiful reminder of this. Made around 1714, it shows symbols of love and entwined initials on the outside, while the inside of the lid is fitted with an intricate

miniature depicting Philip V, King of Spain. The decoration indicates that this box was probably an engagement gift for his second wife, Elisabetta Farnese.

This expensive token of love was also a material declaration of royal support, particularly for gold boxes with portraits. The ability to produce a box with the portrait of a powerful ruler could serve as a useful safe conduct in all sorts of situations. The Venetian adventurer Giacomo Casanova received a box from Clemens August of Bavaria, Archbishop-Elector of Cologne, around 1760. A particularly treasured gift, the box is mentioned repeatedly in his memoirs, although unfortunately it gave away his identity during a masked gambling spree in Venice when it was recognized by a former lover.

Casanova's memoirs show that he was keenly aware of the fine nuances of the choice of material, decoration and the symbolism attached to gestures of giving, receiving and sharing boxes and snuff. Casanova's boxes are handled and go around the table 'two or three times' at gatherings; they are discussed, interpreted even, when snuff is offered or presented. Among the most intriguing and detailed descriptions of gold boxes by Casanova is that of a box he received from a Venetian mistress known for using the disguise of a nun during Carnival: 'The case contained a gold snuff-box, and a small quantity of Spanish snuff which had been left in it proved that it had been used. I followed the instructions given in the letter, and I first saw my mistress in the costume of a nun, standing and in half profile. The second secret spring brought her before my eyes, entirely naked, lying on a mattress of black satin.'

Craftsmen: pan-European networks

Leaving aside the decoration and its hidden qualities, Casanova's vivid description shows the sophistication of gold-box-making in the eighteenth century. The creation of the nun-mistress's box would have involved several skilled craftsmen, each responsible for a single part of the box: a goldsmith to create the frame, including the mechanism of the secret compartment; a miniaturist, and – depending on the decoration – a chaser, enameller

and designer. Gold boxes are highly complex masterpieces, and never the creation of just one maker. They are testament to the creative energy of the craftsmen's quarters in Europe's largest cities, London and Paris. Thanks to affiliations and co-operations – formal and informal, ongoing and occasional – makers responded flexibly and swiftly to even the most extravagant requests from clients and their agents.

Pan-European networks existed alongside local hubs, and journeymen travelled to learn new skills and perfect their art. Emigration for religious or economic reasons also helped to spread the latest innovations in design and technology across the Continent and to London. Therefore some of the eminent makers and artists associated with certain centres of production were not actually born in their adopted home town, such as Swiss-born George Michael Moser in London (no. 40), his fellow countryman Pierre Ador, who trained in London and settled in St Petersburg (no. 43), as well as the Huguenots Daniel Chodowiecki, born in Danzig, and Daniel Baudesson, from Metz, who both made Berlin their home (no. 29). While many goldsmiths can be identified from their marks, the names we know today thanks to inscriptions and signatures on boxes, to inventories and other sources, are very few in comparison to the overall numbers of other specialists who must have been involved in making gold boxes. This is reflected by the many boxes in this book for which no maker could be identified, often because there are no known makers' marks on the piece. In turn, the names of French box makers given in this volume are those associated with the marks found on the respective objects.

The advances in technology over the course of the century were remarkable, and were driven not just by watch-making but also by the manufacture of gold boxes. Three technical innovations in particular had a huge impact on the design of the boxes. In 1709, Johann Friedrich Böttger discovered the recipe for porcelain, and as a result Europe was no longer dependent on China for imports of this extraordinary material. Porcelain became a popular material for boxes and was often set in gold mounts (no. 22).

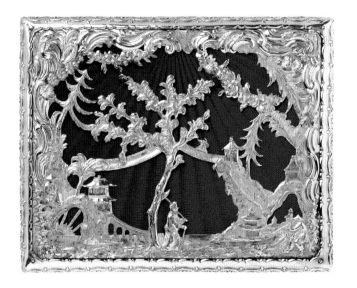

Fig. 10:
Lid of an engine-turned snuffbox
London, *c.1750*
Gold and enamel; the regular,
repetitive pattern visible through
the translucent enamel on this box
was created by engine-turning

For gold boxes, engine-turning or *guilloché* (fig. 10), the technique of mechanically engraving fine, repeat lines or geometric patterns on metal appears to have been first used in Paris in the 1720s.

And from the middle of the century onwards, in response to customers' enthusiasm for gold boxes set with panels of exotic materials, manufacturers developed so-called cage work boxes (fig. 11; no. 25). These were boxes with a skeleton frame set with panels of different materials, which enabled the goldsmith to reduce the amount of gold needed for a box while at the same time allowing for easy exchange of decorative panels when fashions changed or a panel was damaged.

In addition to these innovations and developments, goldsmiths became skilled in the art of creating multi-coloured gold (fig. 1; nos 6, 9), using secret combinations of gold alloys, and artists developed recipes for ever more nuanced and colourful painted enamels.

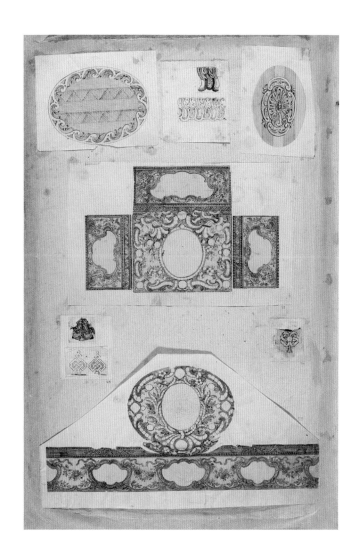

Fig. 11:

Page from an album of goldsmiths' designs, with designs for gold boxes and details of decorations

Paris, *c*.1760

Designs associated with Jean Ducrollay and François Drais, the two successive masters of the workshop

Designers: fast-moving fashions

In 1759, Pierre-Philippe Choffard designed an oval snuffbox (no. 9) that was made by the workshop of Jean Ducrollay near Pont Neuf a year later. What makes the design so remarkable is its style: the comparatively austere, clear forms inspired by antiquity and architectural ornament define this neoclassical design. It is the earliest dated example in this style. The difference is all the more pronounced when the box is compared with other pieces marked for this year: swirly rococo forms dominate a box set with playful enamel plaques after François Boucher (no. 8), made by Ducrollay's competitor Jean Frémin. Ducrollay's workshop also produced similar works around that time, but as the neoclassical piece shows, fashions moved fast, and to be seen in Paris with a box of the previous season would have been completely out of the question for anyone who considered themselves an arbiter of good taste.

Designs for gold boxes range from workshop sketches to presentation pieces that could be discussed with a client and which offer design options for

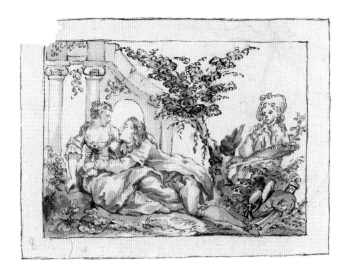

Fig. 12:
**Design for the lid
of a gold box**
France, c.1725–50
Ink on paper

stones and gold (fig. 11). Some could even be folded into a model to give the client a three-dimensional impression of the box. Gold box designs reflect changing fashions in style and subject matter. The light-hearted dominates: from landscapes and architectural fantasies (fig. 1; no. 30), some in Chinoiserie style (nos 18–19), to couples in idyllic landscapes (fig. 12), to frolicking putti (fig. 14; no. 10) performing the tasks of adults or boldly serving as allegories of such serious matters as the liberal arts, science, the four elements or four seasons (fig. 13), sometimes supervised by classical gods (no. 29).

Images based on mythology, popular fiction or classical literature, including Aesop's *Fables* were also sought after. Religious subjects are completely absent. Taking snuff in church was mostly frowned upon – although it seems from literary references that the practice was quite common. Casanova's nun might be the closest brush with religion in eighteenth-century gold box decoration that is known. Instead, many

Fig. 13:
**Design for the lid
of a gold box**
France, *c.*1725–50
Ink and watercolour on paper

Fig.14:

**Six designs for all sides
of a gold box**
Paris, France, *c.1750*
Gabriel Jacques de Saint-Aubin
Pen, ink, watercolour and wash

Design for top and
(*below*) sides of box

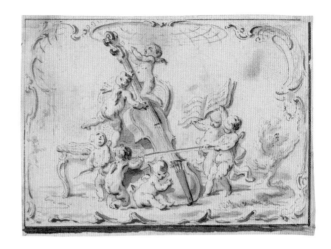

Design for base and
(*below*) front and back of box

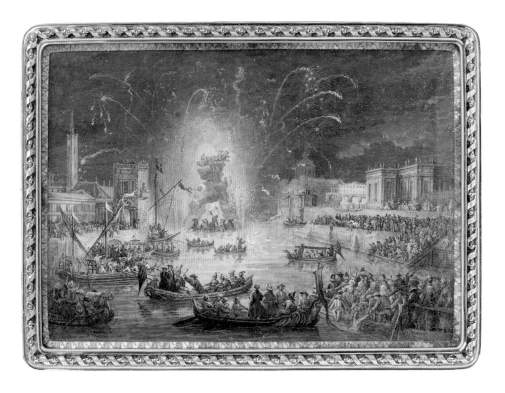

snuffboxes were decorated with coats-of-arms and military scenes; even maps of theatres of war (no. 28) provided commentaries on events of the day. Depictions of domestic, rural and urban life can also be found, while the van Blarenberghe family workshop was unsurpassed as a chronicler of contemporary entertainments such as fireworks (fig. 15), hunts (no. 15) and visits to the opera (fig. 16).

In short, anything that could trigger the imagination and spark a lively conversation was suitable for depiction on a gold box. At the very least,

Fig. 15:
Glazed watercolour miniature of the fireworks display over the Seine
Box: Paris, France, *c.*1870
Painted by a member of the van Blarenberghe family, dated 1761, set in the lid of a gold box

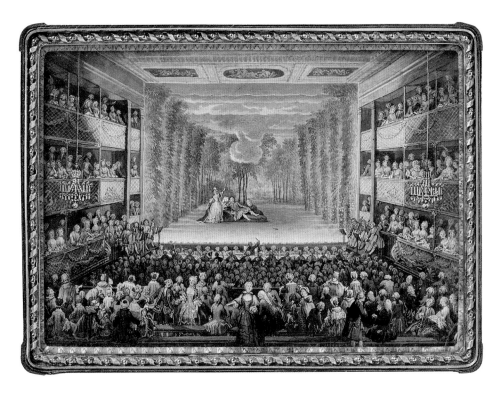

Fig. 16:

**Glazed watercolour miniature
of an opera performance**

Box: Paris, France, *c.1870*
Painted by a member of the van
Blarenberghe family, *c.1761*, set in the
underside of the lid of a gold box

boxes were embellished with floral decorations, grapes (fig. 17), trophies of fruit and gardening tools (surprisingly popular if surviving designs are anything to go by), scientific or musical instruments. Designers working on a particular project could draw inspiration from ornament prints and published designs aimed at such special productions that started to appear in the late seventeenth century (fig. 18).

Collectors

Design and material value made gold boxes not only fashionable but also collectable, a trend already apparent in the eighteenth century (fig. 19). Heinrich Graf von Brühl was prime minister to Augustus the Strong, Elector of Saxony and King of Poland, and one of the most powerful and influential people of his time. He was also a voracious collector of boxes, with more than 800 listed in the inventory compiled after his death. To him, gold boxes were objects to be used for diplomacy, investment, personal adornment and sheer enjoyment, in equal measure.

Across Europe, other noblemen and women also gathered exquisite collections of boxes, but few of similar size to von Brühl's. The collection of the French Prince de Conti was thought to be comparable, but after his death only thirty-four boxes were offered at auction. Most collections were dispersed posthumously, and only sales catalogues or inventories remain to document their riches. An extraordinary exception is the collection of Prince Carl Anselm von Thurn and Taxis whose sixty-nine boxes were first listed in an inventory in 1796. The prince's valet, Adrian Monin, was in charge of purchasing boxes on the prince's behalf. Monin bought mainly in Paris, but also frequented the famous fairs in Leipzig and Frankfurt, where he acquired boxes made in Hanau, a small town near Frankfurt. Hanau is probably unique in terms of the scope of its gold box production, its degree of mechanization and – most importantly – its downright imitation of the designs of Paris boxes during the later eighteenth century. Even the marks used on Hanau boxes deliberately copied Paris marks. Frequently these boxes were attributed to Geneva. Only

Fig. 19:

Design for a combined toilet-table and desk with compartments for snuffboxes

Probably Germany, c.1750–60
Pen, black ink and coloured washes, with framing-lines in black ink
h. 19.5cm, w. 36.3cm

Waddesdon, The Rothschild Collection (The National Trust) Gift of Dorothy de Rothschild, 1971; acc. No. 1731. Photo: Jérôme Letellier © The National Trust, Waddesdon Manor

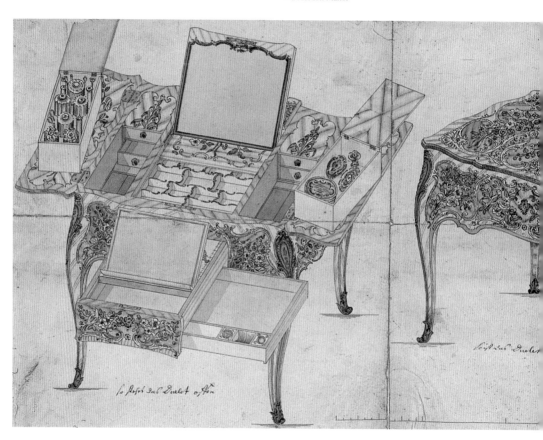

recently German scholar Lorenz Seelig identified Hanau as a major centre for the production of gold boxes in the eighteenth century.

Understanding marks and archive materials is as crucial for interpreting the significance of gold boxes today as the comparison of their designs and imagery. Research continues into the boxes included in this volume. Many of the masterpieces on the following pages were owned by historically important eighteenth-century figures, none more so than the group of table snuffboxes (nos. 25–28) associated with King Frederick II, the Great, of Prussia.

One of the boxes which belonged to Frederick (no. 26) was acquired by Arthur Gilbert from the Thurn and Taxis Collection, through dealer-friends at auction in Geneva. The Rosalinde and Arthur Gilbert Collection of gold boxes is one of the best collections of its kind in the world, and thanks to Charles Truman's two volumes on the Gilbert gold boxes it has also become one of the best known in existence today. The Gilberts had established their own fashion business in their home-town of London in their twenties, specializing in bespoke ballgowns, many with intricate beaded embroidery. When they moved to Los Angeles and made a fortune in property development, their passion for the best in design and craftsmanship prompted them to collect decorative arts. Gold boxes were only one area of interest: they also collected silver and gold, nineteenth-century mosaics and enamels. Transferred to London, the collection has found its new long-term home at the Victoria and Albert Museum.

Rather like their eighteenth-century predecessors, the Gilberts enjoyed handling their snuffboxes and discussing them in detail with their guests and expert advisors. This experience can only be replicated in part in a museum display, and the Gilberts were keenly aware of this limitation when they started lending their treasures to museums. Arthur Gilbert went to the Los Angeles County Museum of Art every Sunday, magnifier in hand, to show his snuffboxes to unsuspecting visitors. This volume aims to serve the same purpose in echoing the tactile appeal of gold boxes while offering the pleasure of exploring their secrets.

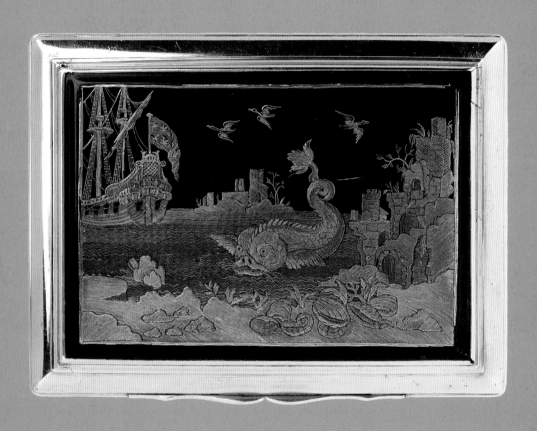

FRANCE

Gold box fashions were set by Paris, and changed rapidly. The city's designers and makers used an excellent network: so-called *marchand-merciers*, luxury goods traders with global links, were at the heart of the industry and often located in close vicinity to the court.

Paris had a strict hallmarking system, known internationally as Touch of Paris, which guaranteed a standard of 19.2 carat gold. Dedicated snuffboxes were first made in Paris at the beginning of the reign of Louis XIV (1643–1715), even though the Sun King despised snuff.

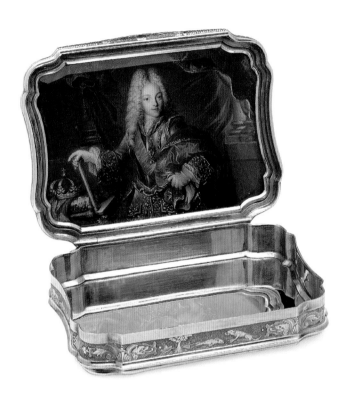

1

Snuffbox with the entwined initials of Philip V of Spain and Elisabetta Farnese

Paris, France, *c*.1714
Gold, turtle shell and
glazed miniature
w. 7cm, d. 5.3cm, h. 1.9 cm

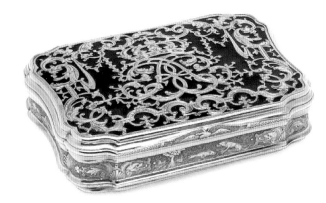

This snuffbox abounds with symbols of love. Doves on the base and hunting scenes around the rim reflect the pursuit of love and marital bliss. The crowned and entwined initials F and E on the lid refer to Philip (Felipe) V of Spain (1683–1746) and his second wife Elisabetta Farnese. The couple married by proxy on 24 December 1714, and the box was probably made around this time as a romantic gift in the context of a highly strategic dynastic marriage.

This box, with its comparatively small dimensions, is an early and highly sophisticated example of a snuffbox; while the nature of the gift is revealed by the imagery on the outside, the miniature depicting Philip reveals the identity of the royal donor only once the box is opened.

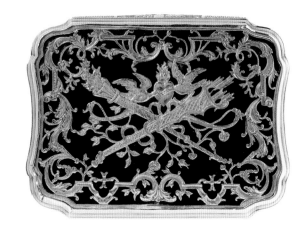

2
**Snuffbox with dolphin
and ship**
Paris, France, 1728–9
Turtle shell inlaid with gold piqué
and glazed miniatures
w. 8.5cm, d. 6.5cm, h. 2.8cm

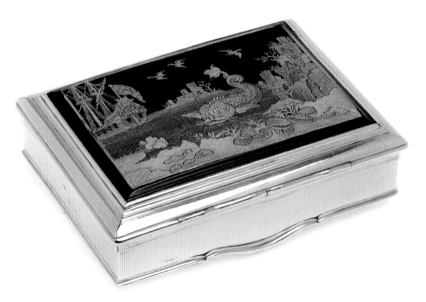

Dauphin (dolphin) was the title given to the heir apparent of France and refers to the depiction of a dolphin on his coat of arms. This box shows the animal in the biologically vague fashion that is typical of the period, paired with a ship flying the French flag. The box can be opened to reveal the portrait of King Louis XV (1710–1774) inside the lid. On the back of the plaque the portrait of his Queen Consort Marie Leszczyńska (1703–1768) can be found. Their first and only son, dauphin Louis, was born on 4 September 1729, and two snuffboxes are recorded in the royal archives as gifts to ambassadors in celebration of the birth.

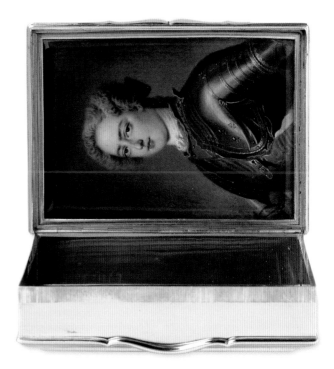

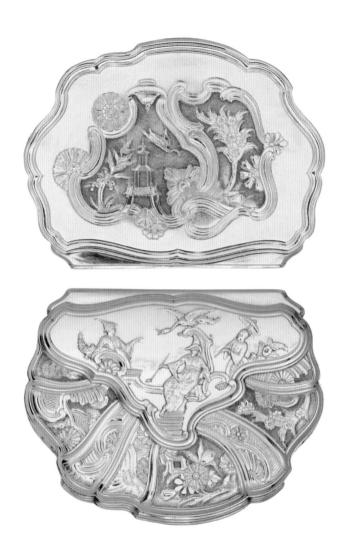

3

**Snuffbox with scenes
in Chinese style**
Paris, France, 1739–40
Jean-Baptiste Devos
(active 1718–60s)
Gold
w. 6.5cm, d. 8.5cm, h. 3.7cm

Jean-Baptiste Devos, the goldsmith whose mark can be found on the inside of this box, was among the eminent makers of boxes with Chinese scenes.

The figures and dragon chased onto its lid reflect the taste for

Chinoiserie in the first half of the eighteenth century. European designers adopted elements of Chinese design, such as the pagoda on the base in their own fantastical style; they were often combined with flowing, asymmetrical rococo motifs.

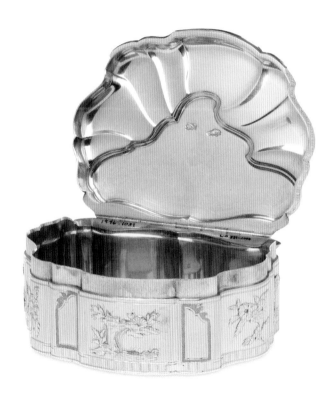

4
Snuffbox with
Minerva welcoming Peace
Paris, France, 1747–8
Claude de Villers (active 1718–55) and
Joseph Vallayer (active from *c.*1745; d.1770)
Gold, enamel, mother-of-pearl and shell
w. 7.8cm, d. 6cm, h. 3.8cm

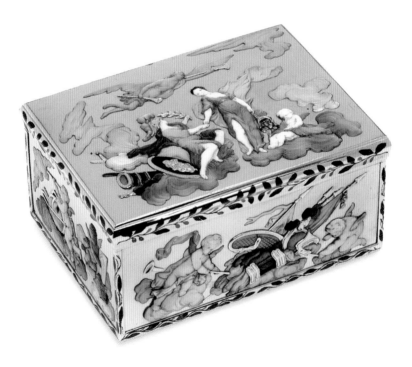

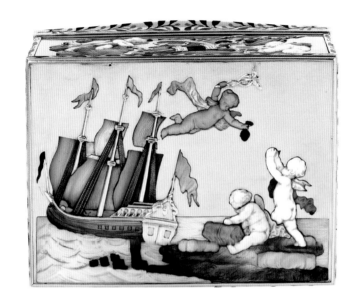

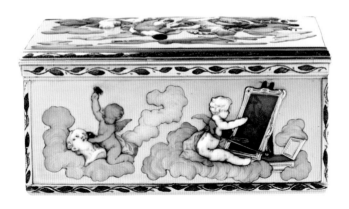

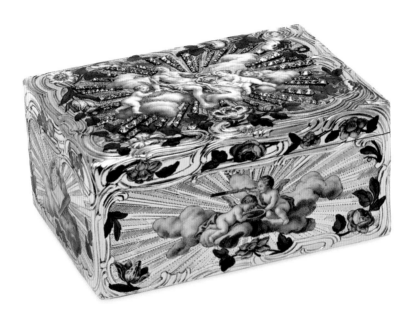

5
Snuffbox with Apollo and emblems of art and science
Paris, France, 1753–4
Jean-François Breton (active 1737–91)
Gold, enamel and diamonds
w. 8cm, d. 6cm, h. 3.8cm

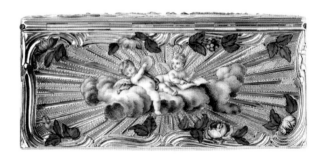

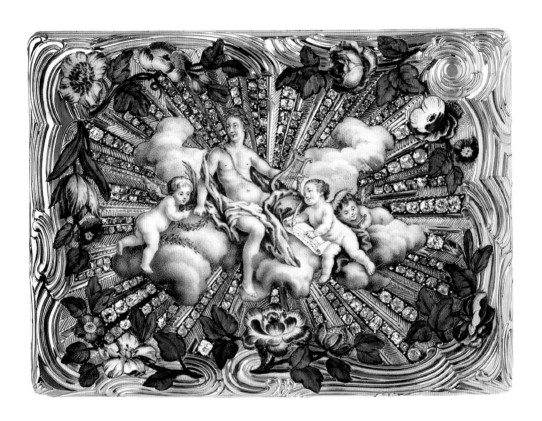

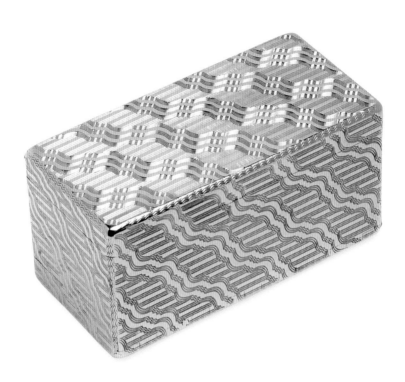

6

Double snuffbox with undulating ribbons
Paris, France, 1754–5
Jean Ducrollay (1710–1787)
Engine-turned gold
w. 8cm, d. 4cm, h. 4cm

This snuffbox has two compartments for tobacco, which are skilfully concealed thanks to the continued pattern and the minuscule hinge. Hinge-making is considered one of the great skills in gold-box-making; the less obtrusive, the greater the art of its maker.

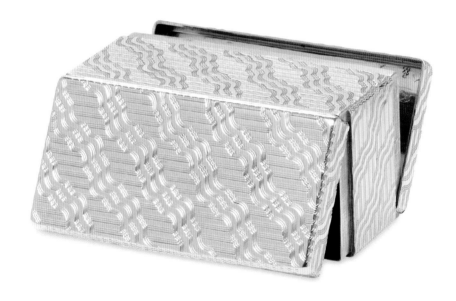

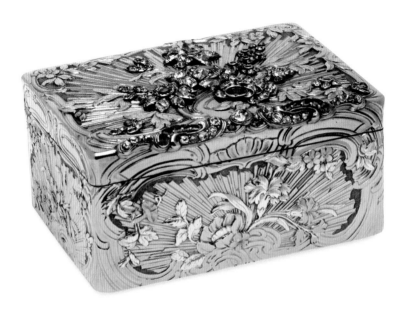

7
**Snuffbox with flowers
and sunburst**
Paris, France, 1755–6
Jean Ducrollay (1710–1787)
Gold, silver, diamonds and rubies
w. 8.2cm, d. 6.1cm, h. 4.4cm

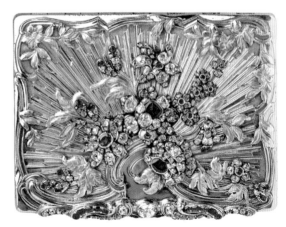

Design for a gold box lid
Paris, France, *c.*1755
Pencil on vellum (skin)
w. 9cm, h. 7cm

Diamond and ruby flowers set in a
varicoloured gold box are explored
in several individual designs that
survive in an album compiled in
the Ducrollay workshop. Between
them is a light drawing of a gold
box lid, which must have been made
at a very early stage of the design
process. The second from the base
on the left, it delineates a bunch of
flowers realistically, leaving it to the
imagination whether it would have
been executed in gold or stones.

Snuffbox with hurdy-gurdy player

Paris, France, 1760–61
Box: Jean Frémin (active 1738–86);
enamels: signed 'Le Sueur'
Gold and enamel
w. 7cm, d. 5cm, h. 3.6cm

From about 1745 onwards, enamelling dominated the decoration of Paris boxes. As the curved shapes popular in the 1730s went out of fashion, snuffboxes offered six blank, flat surfaces that could be filled with any type of decoration. Inspiration came from artists working on the large scale: from painted decorations for the town houses of the Parisian élite, for example. The scene of the little boy and his dog, shown on the lower right page, is inspired by a painting by François Boucher which was engraved by Gilles Demarteau.

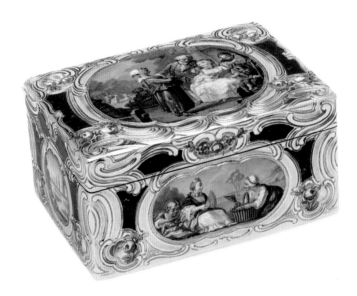

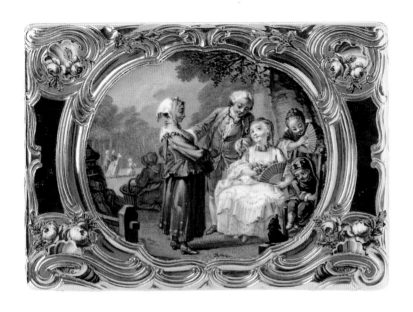

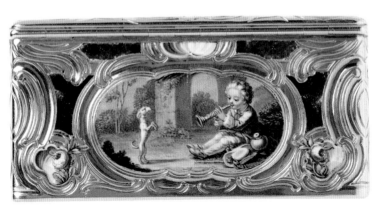

Design for snuffbox;
signed *PP. Choffard fecit 1759*
Ink and watercolour on paper
w. 4.2cm, h. 13.5cm

French master Pierre-Philippe
Choffard provided the maker
Jean Ducrollay with this
design for the box opposite.
Miraculously, the design
survived the centuries in an
album of sketches and prints
produced in the workshop in
Paris, which was located at the
prestigious address of La Place
Dauphine. The purely golden
box was made using different
alloys of gold, which are shown
in Choffard's design by using
subtly different hues.

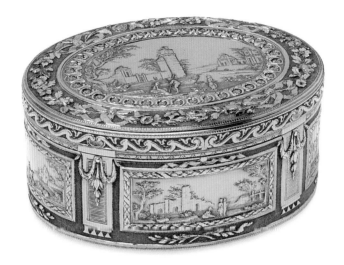

9
Snuffbox with landscapes
Paris, France, 1760–61
Mark of Jean Ducrollay (1710–1787);
design by Pierre-Philippe Choffard
(1730–1809)
Varicoloured gold
w. 8.3cm, d. 6.2cm, h. 3.9cm

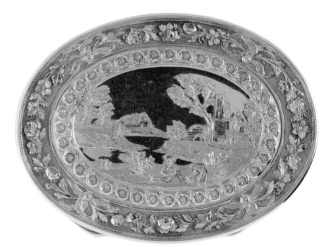

10
Oval snuffbox with putti
Paris, France, 1762–6
Jean Georges (active 1752–65)
Gold and enamel
w. 8.5cm, d. 6.2cm, h. 4.2cm

Oval snuffboxes with elegant
painted enamel decoration
were immensely popular during
the 1760s and beyond. Their
enduring appeal is shown by the

two later examples opposite.
One of them was made in
Hanau, Germany, which
flourished as a centre of gold
boxes in Paris style.

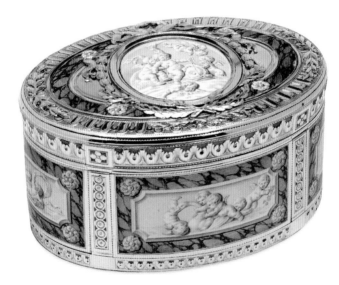

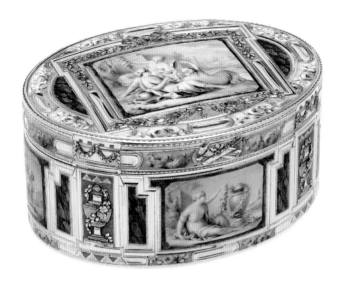

Oval snuffbox
with nymphs and putti
Paris, France, 1768–9
Jean Frémin (active 1738–86);
enamels: Claude Bornet
w. 8.4cm, d. 6.4cm, h. 4cm

Diamond-set snuffbox
with Hector
Hanau, Germany, c.1780
w. 8.5cm, d. 6.3cm, h. 3.8cm

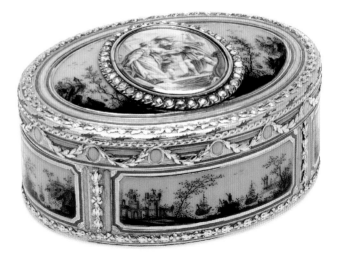

11

**Oval snuffbox with dogs
and a cat**
Paris, France, 1763–4
François-Nicolas Génard
(active 1754–90)
w. 7cm, d. 5.5cm, h. 4.7cm

Dogs dominate the carefully
enamelled decorations of this
box, which is small in comparison
to other oval boxes. Dogs are
a common symbol of fidelity,
friendship and loyalty. Here they
are shown as playful companions

on the lid, and as solitary creatures
on the wall of the box. Below
the hinge on the back, an elegant
white cat looks directly at the
viewer. It sits on a dressing table
next to a mirror, candlestick and
small needle pillow.

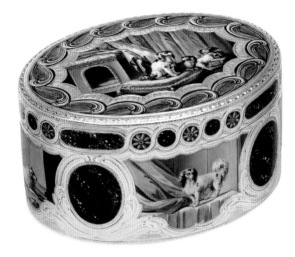

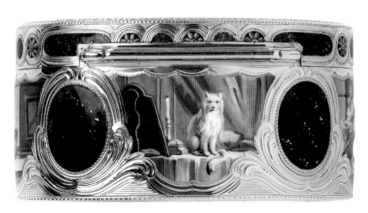

12

Box in the shape of an egg
France; box: Sèvres, 1764–5;
mounts: Paris
Soft-paste porcelain,
enamel colours and gold
diam. 4cm, h. 6cm

Egg-shaped boxes were particularly
popular in England in the late
eighteenth century. This example,
a rarity for the Sèvres porcelain
factory, might therefore have been
made for an English customer.

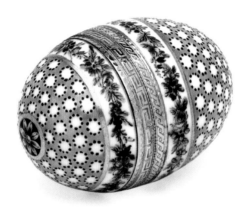

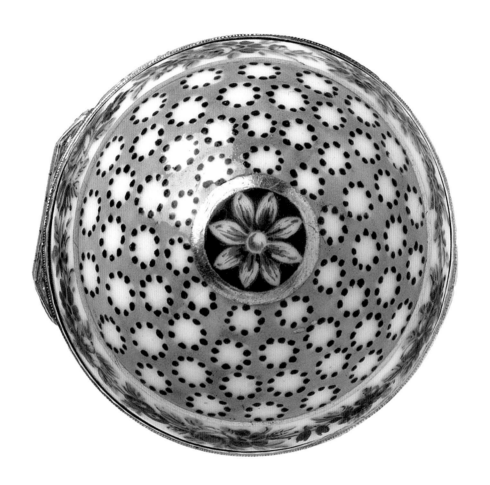

13

Snuffbox with Japanese lacquer panels

Paris, France, 1774–5
Pierre-Genest Leguerinière
(1726–after 1793)
Gold and Japanese *kiji-nuri* lacquer
w. 7.5cm, d. 5.6cm, h. 3.3cm

This box is set with ten panels of Japanese *kiji-nuri* lacquer. Contemporary to the mounts, they were probably made for export to Europe. *Kiji-nuri* (direct lacquer) is a technique of painting on wood which incorporates the grain of the wood into the decoration. The box features genre scenes, a musician and her admirer on the top, and wood carriers on the base shown opposite.

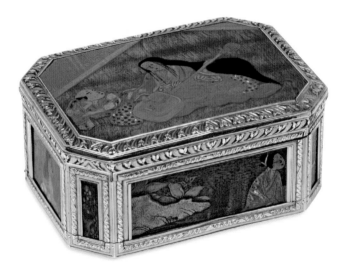

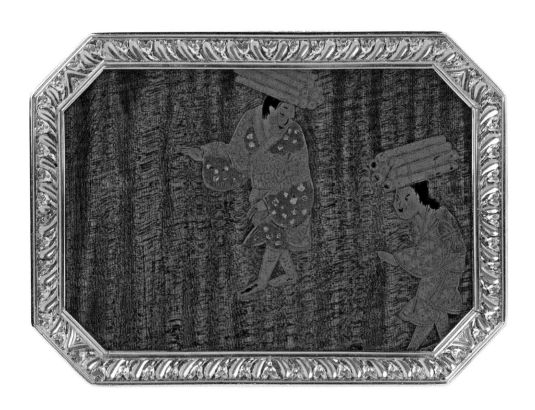

14
Snuffbox with mythological scenes
Paris, France, 1772–3
Pierre-François Drais (active 1763–88); chasing: probably Gérard Debèche fils (active 1740s–70s)
Gold, enamel and glass
w. 8cm, d. 4cm, h. 3.5cm

Pierre-François Drais was the pupil and cousin of the famous goldsmith Jean Ducrollay. He worked with a chaser named Gérard Debèche on a gold box for Marie Antoinette's wedding. The intricately chased gold medallions on the lid and base of the box are protected by glass domes.

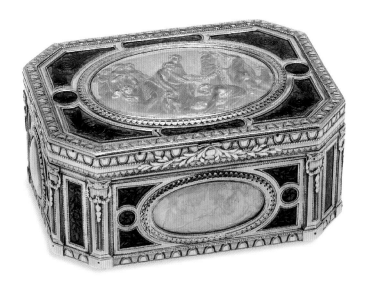

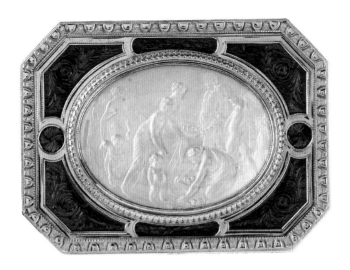

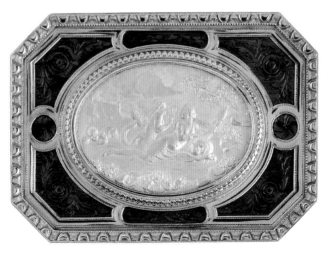

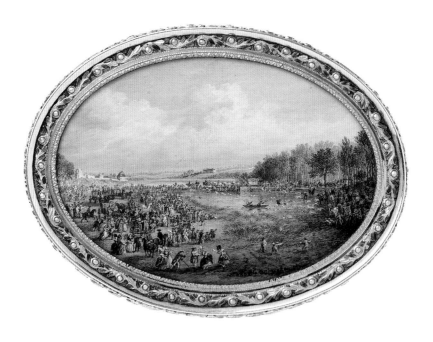

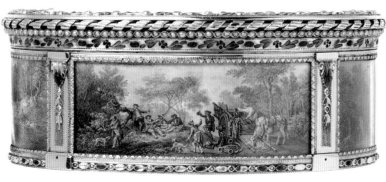

15

Snuffbox with hunting scenes
Paris, France, 1777–9
Box: Pierre-François Drais (active
1763–88), signed *Drais Bijoutier du Roy
a Paris*; miniatures: a member
of the Blarenberghe family, signed
van Blarenberghe
Gold, pearls, enamel and
glazed miniatures
w. 8.8cm, d. 6.7cm, h. 3.5cm

During a court hunt on 13 July 1740,
King Louis XV of France pursued
a stag that sought refuge on a roof.
The incident is depicted on the lid
of this exquisite box, which was
allegedly owned by the King. In
1824 his descendant Louis XVIII

presented the box to André Huë, a
descendant of the *greffiers de chasse*,
record-keepers of the royal hunt,
at Fontainebleau. The detailed and
vivid miniatures are by a member
of the van Blarenberghe family, a
dynasty of at least five miniaturists.

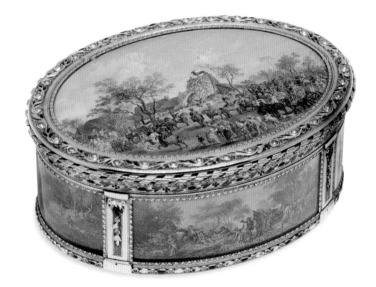

16

**Snuffbox with cockerel
and flowers**

Paris, France, 1819–32
Gabriel-Raoul Morel (1764–1832)
Coral, ivory, mother-of-pearl,
burgau shell, gold and composition
w. 8cm, d. 6.1cm, h. 3.8cm

The technique used for the panels of
this box is known as *Laque Burgauté,
burgau* being the French word for
the sea-ear (Haliotis) or abalone.

The shell, famous for its iridescent
shimmer, is used alongside other
materials which have been inlaid
into lacquer panels.

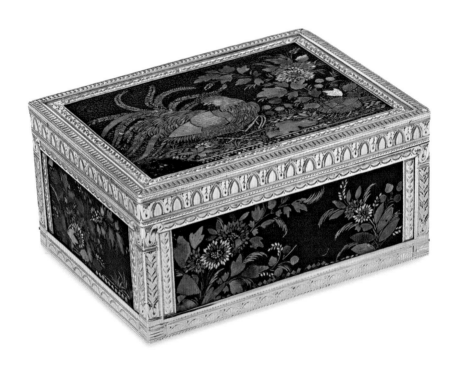

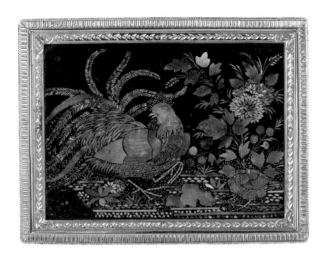

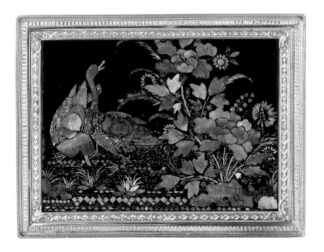

GERMAN STATES

The princes of the states in modern-day Germany and Austria were clearly influenced by Parisian affairs and fashions, and purchased Paris boxes. While inspired by the taste of Paris, makers in several residence cities developed their own distinct, at times almost idiosyncratic style and range of materials, among them figural boxes in porcelain and snuffboxes created as encyclopaedias of mineralogy.

Frederick the Great, King of Prussia (r. 1740–86), surpassed every other ruler in Europe in regard to the ambition of his gold box commissions. He banned imports from Paris upon ascending the throne in 1740; to him, lavish patronage was a regal duty. It is known that he even provided preliminary designs for gold boxes. His boxes, too precious, large and heavy to be used as accessories, were displayed on special tables at his palaces. Camels, with their soft, even walk, carried the fragile treasures from residence to residence.

17

Hunting snuffbox
Probably Germany, *c.*1730
Gold, mother-of-pearl and
glazed miniature
w. 8.2cm, d. 6cm, h. 3.3cm

The miniature on the inside of this
box is based on an engraving from
the popular series, *Die Par-Force Jagd*
(The Par-Force Hunt) by Johann
Elias Ridinger (1698–1767), published

in Augsburg in the 1730s. The South
German city was an eminent centre
of publishing and goldsmiths' work,
and led style in particular during the
first half of the eighteenth century.

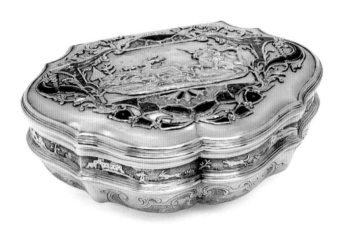

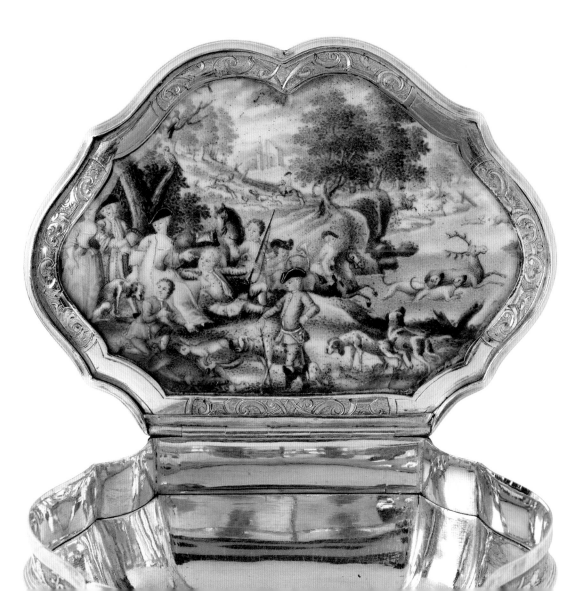

18

**Snuffbox with a Chinese
lion-dog and cub**

Probably Dresden, Germany, *c.*1750
Possibly the workshop of Heinrich
Taddel (1715–94)
Gold, silver, quartz and burgau shell
w. 8.9cm, d. 6.7cm, h. 2.9cm

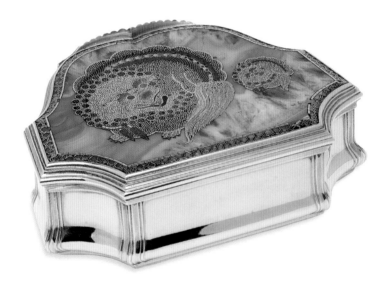

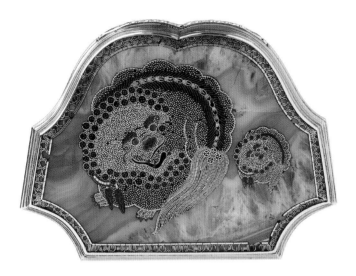

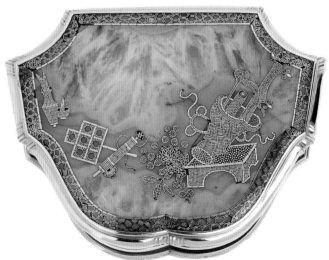

19

**Snuffbox with Chinese fan
and vases**

Probably Dresden, Germany, *c.*1750
Possibly the workshop of Heinrich
Taddel (1715–94)
Gold and lapis lazuli, inlaid with
burgau shell, gold and composition
w. 6.2cm, d. 4.8cm, h. 3cm

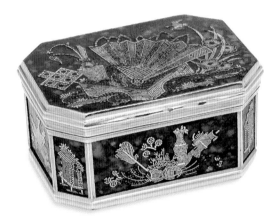

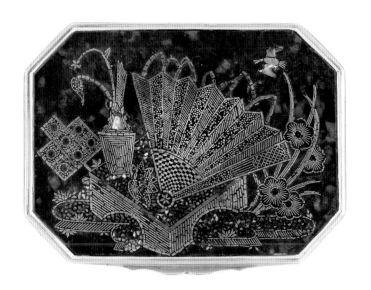

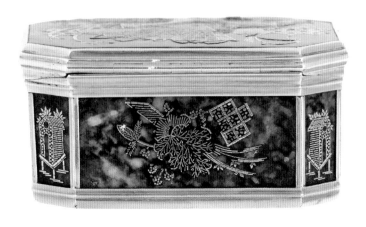

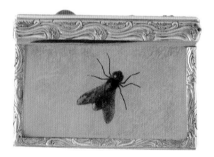

20

Snuffbox with flowers and insects

Berlin or Dresden, Germany, 1760–70
Friedrich Ludwig Hoffmann (active 1760s), signed on base E.L.HOFFMAN F.
Quartz, gold and hardstones
w. 7.3cm, d. 5.3cm, h. 3.9cm

Life-like insects are set into the cloudy quartz of the box as raised stonework, a technique practised in Berlin and Dresden. In 1762 Hoffmann was recorded as a stone-cutter in Bayreuth, and might have moved to Berlin in 1763. The links between the two cities were strong since Wilhelmine of Prussia, Margravine of Brandenburg-Bayreuth (1709–1758), was the older and favourite sister of Frederick the Great, King of Prussia.

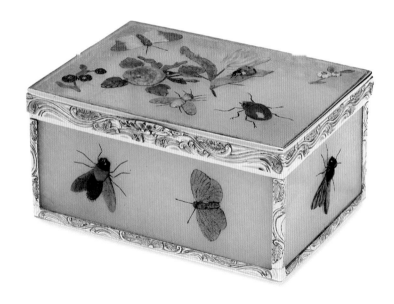

Snuffbox with three snuff compartments

Germany, *c*.1750
Box: Meissen porcelain factory; decoration: probably Johann Martin Heinrici (1713–1786); mounts: Dresden
Hard-paste porcelain, enamel colours and gold
w. 8.8cm, d. 7.2cm, h. 5.3cm

Three different types of snuff could be held in this box, which has two lids on the top (both sides) and a third lid on the base. The double lids on the top show the Roman gods Mars and Minerva on the outside and reveal portraits of Charles-Theodore, Elector of Bavaria (1724–1799) and his wife when opened. The inside of the hinged base shows the Rape of Europa by Jupiter, in disguise as a white bull.

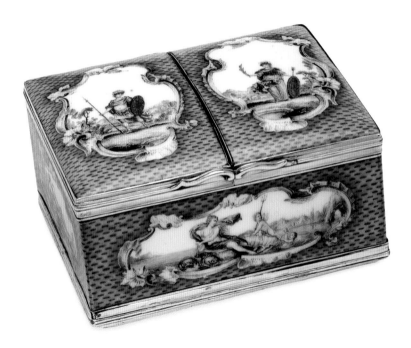

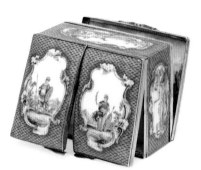

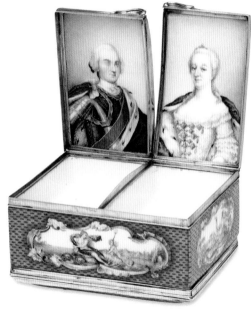

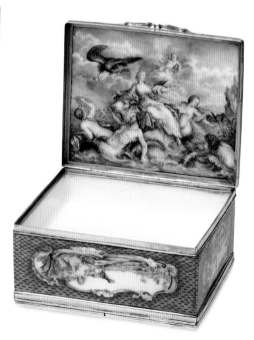

22

Snuffbox in the shape of a letter

Germany, *c.1755*
Box: Meissen porcelain factory;
view of London after Matthaeus
Merian (1638, which in turn follows
the 1616 panorama of London
published by Claes J. Visscher);
mounts: possibly Dresden
Hard-paste porcelain, enamel
colours and gold
w. 8.8cm, d. 5.6cm, h. 2.6cm

Snuffboxes decorated as letters
were a signature product of
the Meissen porcelain factory.
They could be personalized with
messages such as '*A la plus Fidelle
Partout où Elle se trouve*' (To the most
faithful, wherever she is found). The
view of London in the lid follows
seventeenth-century prints.

This might be the reason why the
view shows an area east of St Paul's
Cathedral as the most recognizable
eighteenth-century landmark: the
prints show the Gothic building
destroyed in the Great Fire of
1666. It had long been replaced by
Christopher Wren's cathedral when
the box was made.

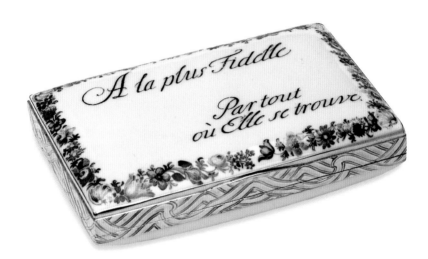

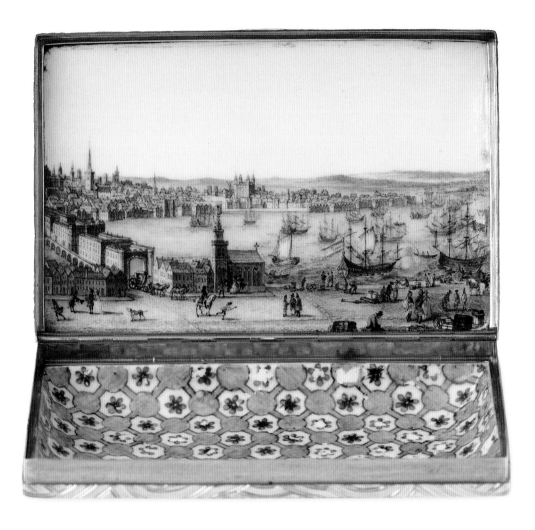

23

**Snuffbox in the form
of a sheep**
Probably Dresden, Germany, *c.*1755
Amethystine quartz, gold, silver,
diamonds and rubies
w. 8.3cm, d. 5.4cm, h. 4.8cm

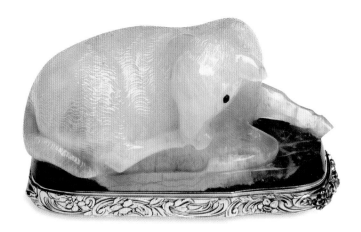

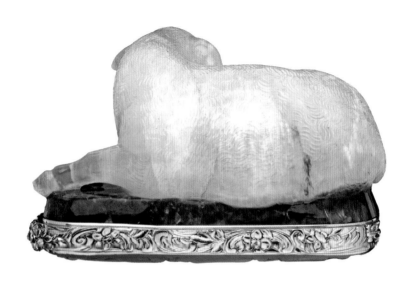

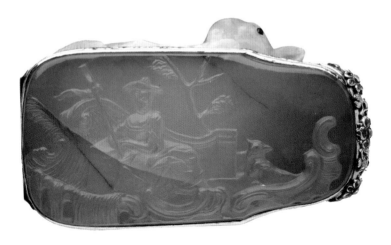

24

Steel snuffbox with gold decoration
Possibly Germany, *c.1755*
Steel, with false damascening in gold
w. 8.7cm, d. 6.7cm, h. 4.2cm

The techniques and materials used in this steel and gold box are more typical of armourers than box-makers. It may therefore have been made by a specialist in the decoration of weapons, perhaps to accompany a decorated sword hilt. The box has been chased, engraved and then 'case-hardened',

that is, heated and plunged into oil, producing an attractive blue lustre. The surface was then decorated with false-damascening, in which gold is applied to a cross-hatched base-metal surface, rather than 'true damascening' in which gold is laid into grooves cut into the metal.

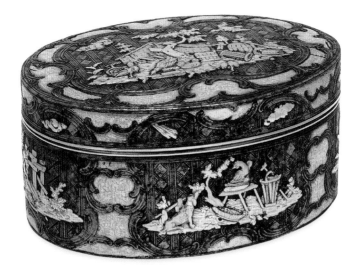

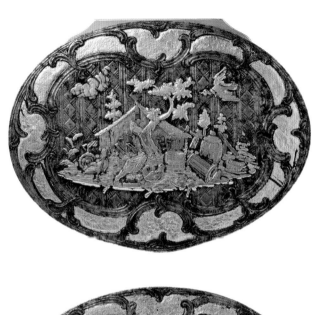

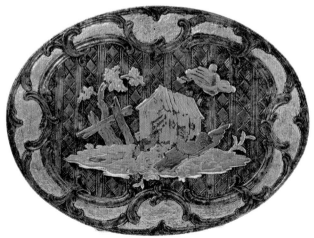

25
Table snuffbox
Berlin, Germany, *c.1765*
Mother-of-pearl, gold, diamonds,
rubies, emeralds, sapphire, spinel,
amethyst, turquoise, hardstones,
glass and foil
w. 10cm, d. 8.1cm, h. 5.2cm

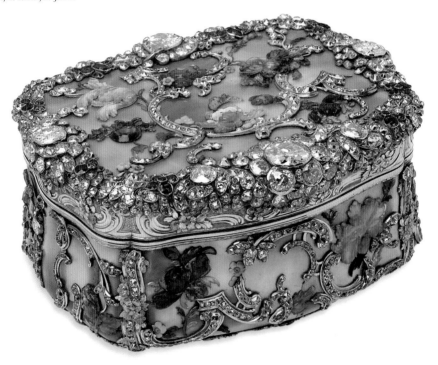

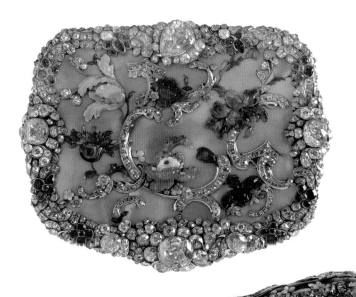

Frederick the Great, King of
Prussia, amassed an extraordinary
collection of up to 400 individual
snuffboxes. He also took a keen
interest in the design of the boxes,
and commissioned large, heavy
but nonetheless playful boxes. The
complex designs were explored
through models in wood and wax.
This box is a cage work gold frame
in which the mother-of pearl panels
with their gem flowers were set.

26
Snuffbox with diamond flowers

Berlin, Germany, *c.*1765
Agate, gold, diamonds,
hardstones and foil
w. 10cm, d. 7.3cm, h. 5.2cm

The rim of this box is inscribed (in German): 'I belonged to Frederick the Great. Frederick William III gave me to his son Albrecht as the inalienable property of his family'. The box opposite was probably given by Frederick the Great to the princes of Thurn and Taxis.

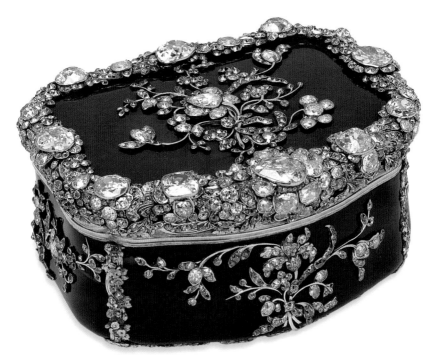

Table snuffbox with vase of flowers
Berlin, Germany, 1775–80
Based on a design by Jean Guillaume
George Krüger (1728–1791)
Bloodstone, gold, silver, diamonds,
emeralds, rubies, hardstones, glass
and foil
w. 9.5cm, d. 7.3cm, h. 5.4cm

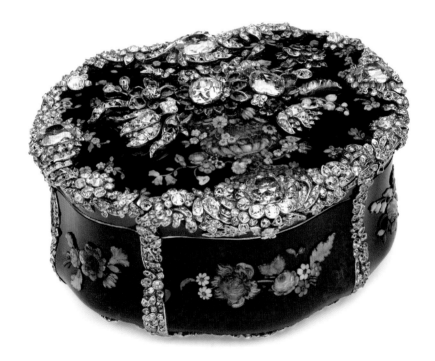

27
Table snuffbox
Berlin, Germany, *c.*1765
Chrysoprase, gold, diamonds,
hardstones and foil
w. 10cm, d. 7.8cm, h. 5cm

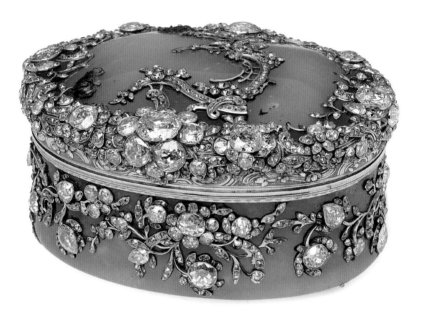

Frederick the Great also had a
particular preference for the green
stone chrysoprase, and allegedly
even asked to be shown boxes
in this material on his deathbed.
The light beauty of the box is in
stark contrast to the story told by
the stone: chrysoprase was found
in Silesia, which became part of
Prussia as a result of Frederick's
military campaigns, commemorated
in the maps of the silver box medal.

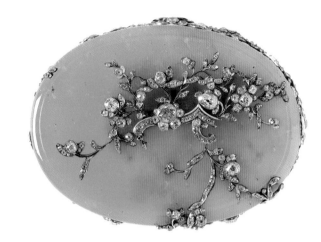

Box medal with portrait of Frederick
the Great and miniature maps of
battlefields in the Seven Years' War
Bern, Switzerland, 1759–63
Johann Melchior Morikofer,
G. Eichler and B. Hubner
Silver and engraving
diam. 5.1cm, h. 0.9cm

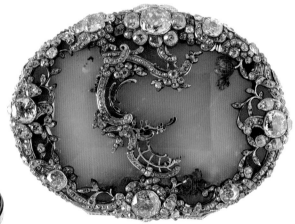

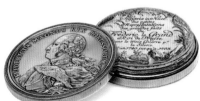

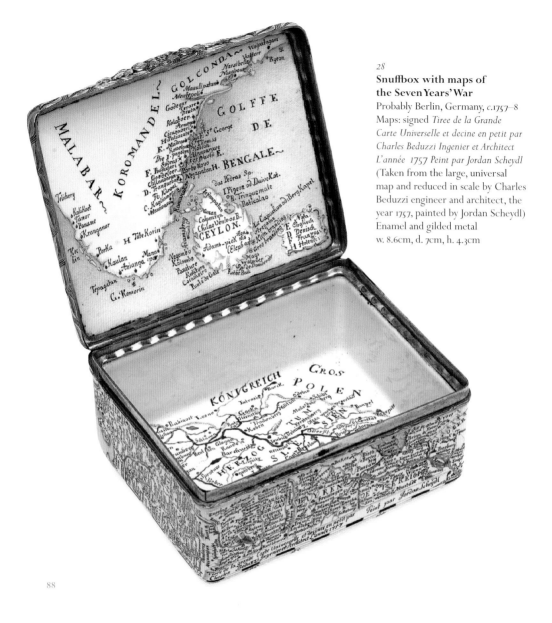

28

**Snuffbox with maps of
the Seven Years' War**
Probably Berlin, Germany, *c.*1757–8
Maps: signed *Tiree de la Grande
Carte Universelle et decine en petit par
Charles Beduzzi Ingenier et Architect
L'année 1757 Peint par Jordan Scheydl*
(Taken from the large, universal
map and reduced in scale by Charles
Beduzzi engineer and architect, the
year 1757, painted by Jordan Scheydl)
Enamel and gilded metal
w. 8.6cm, d. 7cm, h. 4.3cm

The disputed sovereignty of Silesia, which is depicted on a map inside this box, triggered the Seven Years' War (1756–63). The duchy had become Prussian territory during the War of the Austrian Succession (1740–48) when Frederick the Great, King of Prussia, defeated Empress Maria Theresa of Austria. All major European powers became involved. Colonial interests outside Europe led to an escalation of the war into what might be considered the first global conflict.

Berlin and Vienna, opposing parties in this conflict, were the main centres of production of enamelled copper snuffboxes. Given Prussia's triumphs on the battlefields depicted on the box, Berlin appears the more likely origin, though artists with names comparable to those on the box can be found in Viennese records.

29
**Oval snuffbox with
putti and Minerva**
Berlin, Germany, 1755–70
Box: Daniel Baudesson (1716–1785);
enamels: probably Daniel
Chodowiecki (1726–1801)
Gold and enamel
w. 9.5cm, d. 5cm, h. 4.3cm

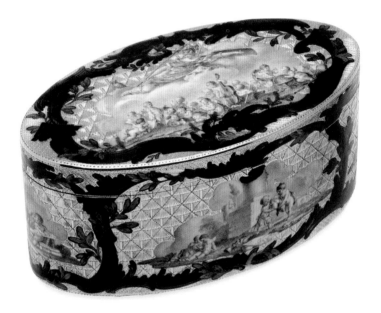

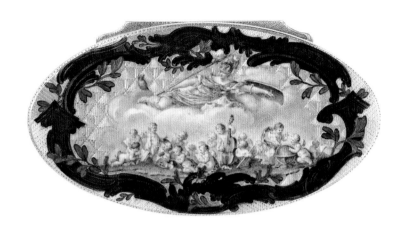

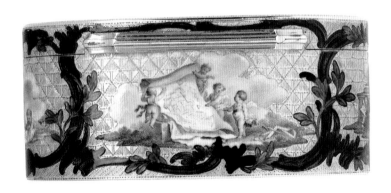

30
Snuffbox with classical landscapes
Possibly Berlin, Germany; or
St Petersburg, Russia, c.1768
Maker's mark: PAG
Gold, silver, diamonds and foil
w. 8.7cm, d. 7cm, h. 4.2cm

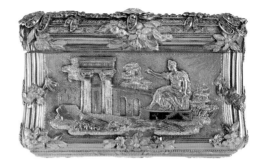

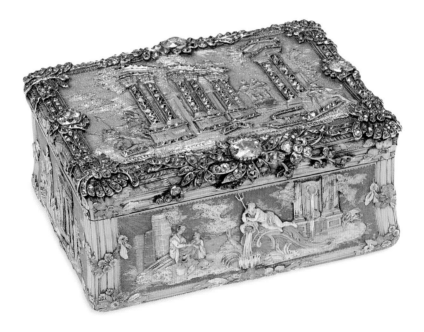

Thomas Dimsdale (1712–1800), an English doctor, advised Empress Catherine II of Russia (r.1762–96) during the Russian smallpox epidemic of 1768. So impressed was Catherine by the success of the potentially dangerous inoculation against the disease that Dimsdale was created a Baron of the Russian Empire, a councillor of state and personal physician to the Empress. He was also awarded the princely sum of £10,000 plus an annuity and works of art. His son, Nathaniel, was presented with this magnificent snuffbox by Catherine's son, Tsarevich Paul, 'as a testimony of his regard'.

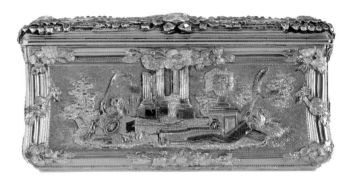

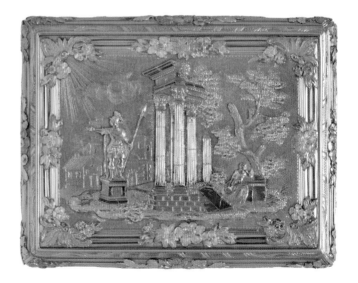

31

**Snuffbox with sunburst,
man and dog**

Dresden, Germany, *c.*1780
Attributed to Johann Christian
Neuber (1736–1808)
Gold, agate, carnelian and glazed
miniature inside the lid of Frederick
Augustus III, Elector of Saxony, after
Anton Graff (1736–1813)
w. 8.1cm, d. 6.1cm, h. 4.2cm

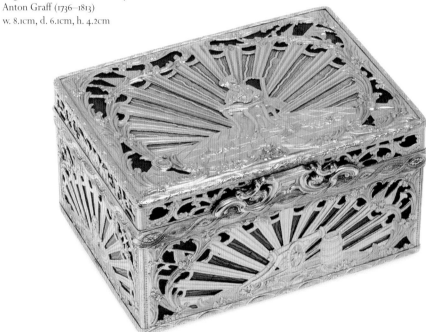

Peace and victory are the subjects of this box, which might have been made to celebrate the Treaty of Teschen at the end of the War of the Bavarian Succession in 1779: a sleeping dog keeps a man company who has laid down his arms and seems about to sign a document. All stones originate from Saxon quarries where Neuber had princely permission to prospect for suitable stones. Among his signature products of the 1780s were *Steinkabinette*, mineralogical snuffboxes, as shown below.

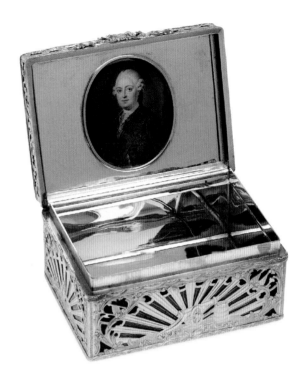

Snuffbox with collection of mineralogical specimens
Dresden, Germany, c.1785–90
w. 6.8cm, d. 5.1cm, h. 2.2cm

This *Steinkabinett* is set with sixty-seven hardstone specimens, all of them mined in Saxony and listed in a separate booklet, hidden inside the box.

Bonbonnière with micromosaics

Germany and Italy, *c*.1780
Box: probably Johann Christian
Neuber (active 1736–1808), Dresden;
glass micromosaics: Rome, the top
probably Giacomo Raffaelli
(active 1753–1856)
Hardstones, gold and glass
micromosaic
diam. 7.7cm, h. 3.3cm

The term 'micromosaic' is used
to describe mosaics made of the
smallest glass pieces, which were
first produced in Rome during
the second half of the eighteenth
century. The mosaic of a white dog
on the lid of this box was a

fairly popular subject matter on
such miniature plaques from
Rome. The butterfly depicted
on the base of the box consists
of slightly larger tesserae, and
would have taken less time to
complete.

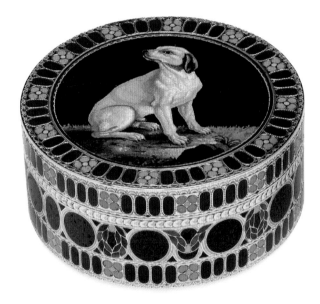

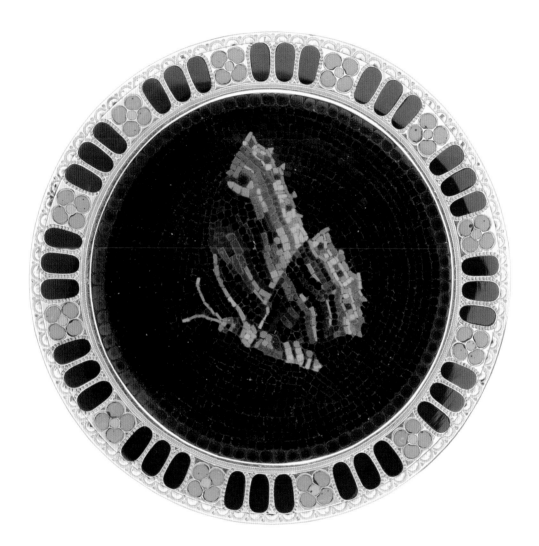

33
Snuffbox with Venus, Mars and Cupid

Vienna, Austria, c.1780
Box: Pierre Michel Colas (active 1763–81); enamels: Philipp Ernst Schindler II (1723–1793)
Gold and enamel
w. 6.9cm, d. 5.1cm, h. 3.8cm

The painted enamels on this box are executed *en grisaille* (in grey), to resemble the texture of stone. The effect is that of an ancient cameo. Schindler worked in Vienna, the unrivalled capital of the German-speaking countries at the time and residence of the Emperor of the Holy Roman Empire. His clientele would have demanded French fashion, and Schindler obliged them: many of his miniature panels were adapted from engravings after François Boucher.

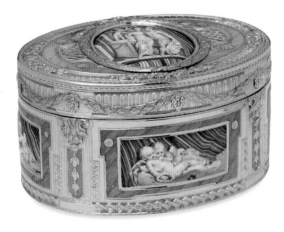

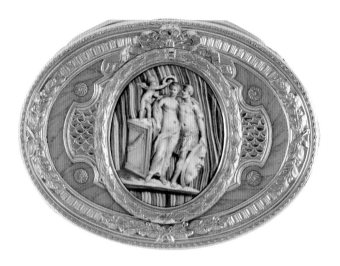

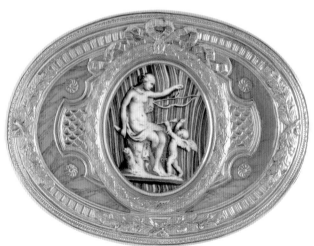

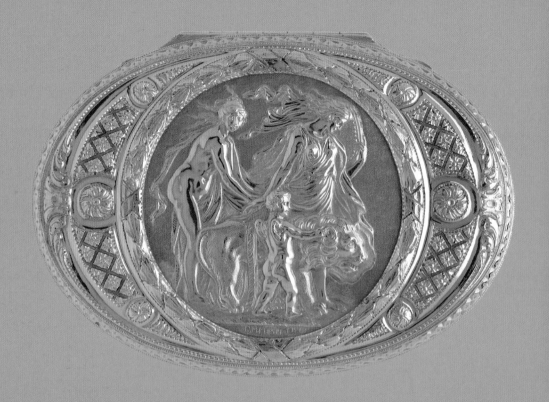

GREAT BRITAIN

In the eighteenth century, London was home to an ever-growing community of international craftsmen and the national centre of production for luxury goods. The rapidly growing city had a very diverse and young population. Just as their makers, gold boxes created in London show their Continental heritage: chasers of German origin and enamellers and engravers of Swiss origin worked alongside the large Huguenot community of goldsmiths. Not all of them stayed in London; makers moved in search of the most promising markets across Europe, as the example of Pierre Ador shows: originally from Switzerland, he learnt in London and eventually settled in St Petersburg.

34
Snuffbox and scent bottle in the form of a hunter and dog
Probably London, England, *c.*1760
Gold, agate, diamonds and enamel
w. 9.8cm, d. 7cm, h. 9.3cm

The dog's head is detachable and linked to the main box with a slender gold chain. FIDÈLE ET SINCÈRE (faithful and sincere) reads the inscription on the dog's enamelled collar. Snuff can be kept in the compartment underneath the hinged agate base of the figure. The

scene on the base, of a huntsman astride a stag, after Johann Elias Ridinger's hunting prints, shows the pan-European fame of the work of the Augsburg-based engraver and publisher. The box was once owned by tenor Enrico Caruso (1873–1921).

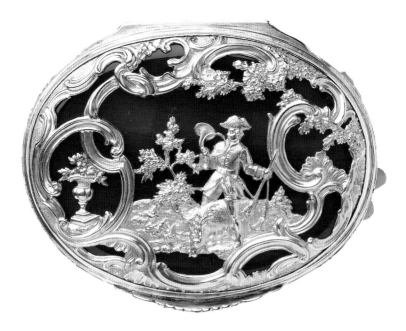

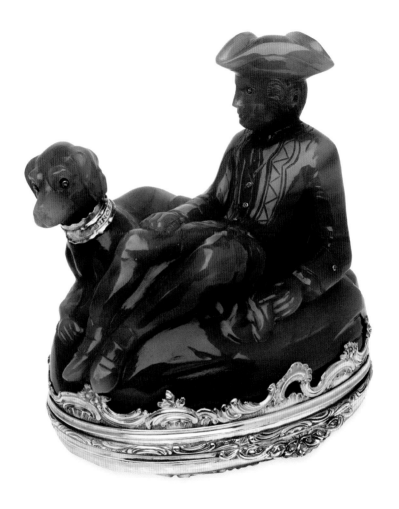

35
Tontine snuffbox
London, England, 1764
Box: Jasper Cunst (active 1721–76);
enamel: George Michael Moser
(1706–1783)
Gold and enamel
w. 8.8cm, d. 6.5cm, h. 3.5cm

A tontine was an early form of investment club: the proceeds went to the last surviving member. Sir Charles Price, speaker of the House of Assembly of Jamaica, whose arms are on the lid, was the longest surviving member of the tontine club commemorated by this box. The enamel on the inside of the lid lists the names of the other members with their respective dates of death.

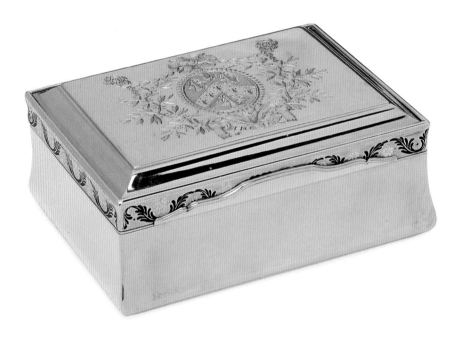

TH̄O ROSE, ESQ. OB. 24 NOV. 1724.
WOODYER MASON, ESQ. OB. 13 AUG. 1730. ÆT. 32.
ANN BLAIR. OB. 28 NOV. 1737. ÆY. 17.
G. ELY. AR. OB. 5 JAN. 1737/8. ÆY. 69.
IGNAT. DUANY, AR. OB. 17 NOV. 1739. ÆT. 55.
JOHN PRICE, AR. OB. 4 FEB. 1739/40. ÆT. 24.
PHILIP REDWOOD. OB. 10 AP. 1741. ÆT. 42.

...EN. DAWKINS, AR. OB. 30 JUNE 1744. Æ.49 RICH. BALHED, ESQ. OB. 12 JUL. 1743. Æ. 7.
...JOHN SEROCOLD. OB. 19 JUL. 1744. Æ. 57 ALD.RIC BECKFORD. OB. 24 JA. 1738. Æ.44.
...WILL. NEDHAM, AR. OB. 1 JUL. 1746. Æ. 77 MrELIZ. DAWKINS. OB. 19 AUG. 1737. Æ. 60.
...T. ROSE PRICE, ESQ. OB. 22 MAY 1749 SAM. DAWKINS, AR. OB. 15 SEP. 1747. Æ. 14.
...ALEX. INNES, ESQ. OB. 17 JU. 1749. Æ. 56 JOHN WALTER, ESQ. OB. 21 AUG. 17. SE. Æ.59.
...GEO. GALBRAITH, OB. 23 MAR. 1750. Æ 35 JANET PRICE, OB. 7 DEC. 1745. Æ. 27.

105

36
Snuffbox with flowers
Probably London, England, *c.*1755
Mother-of-pearl and gold
w. 6.8cm, d. 5.6cm, h. 3cm

This box exemplifies techniques,
materials and ornament that were
popular across Europe around the
mid-eighteenth century. The earlier
French design opposite shows that
the motif as such was first explored
in Paris. This box is unmarked, and
therefore any attribution remains
tentative.

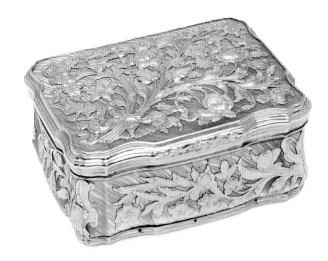

Design for the lid of a snuffbox
France, c.1725–50
Watercolour and ink on paper
h. 6.1cm, w. 8.8cm

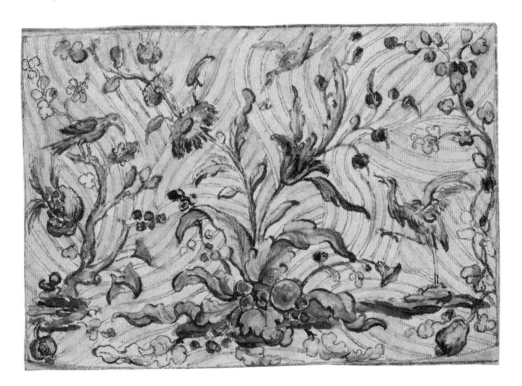

37

**Snuffbox in the shape
of a girl's head**

England, 1760–65
Box: London, Chelsea porcelain
factory; mounts: possibly
Birmingham
Soft-paste porcelain, agate,
diamonds, enamel colours and gold
w. 4.4cm, d. 5.3cm, h. 5.1cm

JE TE CONNAIS BEAU MASQUE (I know
you beautiful mask) is inscribed on
the rim of the lid of this charming
box. As the male companion shown
below demonstrates, the Chelsea
porcelain factory offered several
models of snuffboxes as heads
during this period.

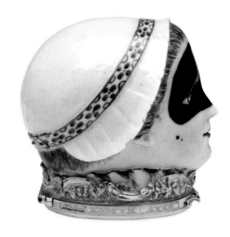

*Snuffbox in the shape
of a man's head*
England, c.1759–69
Box: London, Chelsea
porcelain factory
w. 5.7cm, h. 6.9cm

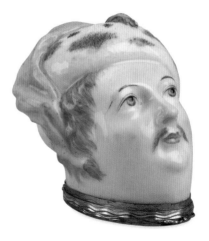

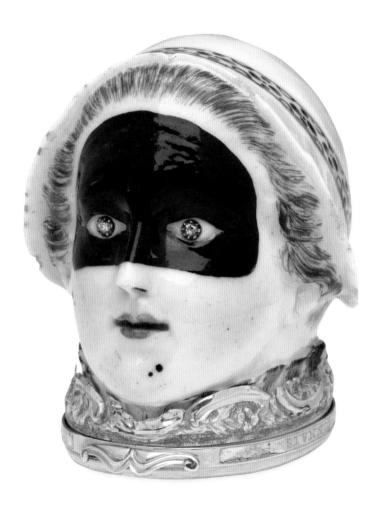

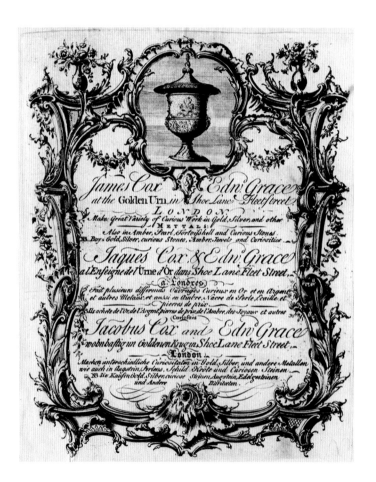

Trade card for James Cox
London, England, *c.*1751–7
Etching with engraved
lettering
h. 20.7cm, w. 16.1cm
©The Trustees of the
British Museum/Heal,
67.99

38

**Automaton snuffbox
and watch**
London, England, 1766–72
James Cox (active 1749–91)
Gold, moss agate, glass and
clockwork mechanism
w. 7.9cm, d. 6.6cm, h. 5.1cm

The maker of this box, James Cox,
was a household name as jeweller
and 'toymaker' in eighteenth-
century London. His trade card
states – in English, French and
German – that he offered 'a
great variety of Curious Work
in gold, silver, and other metals

also in amber, pearl, tortoiseshell
and curious stones'. Cox was an
entrepreneur and reported in
the 1770s that he employed up to
1,000 workmen. In 1772 he opened
a museum in Westminster for his
automata.

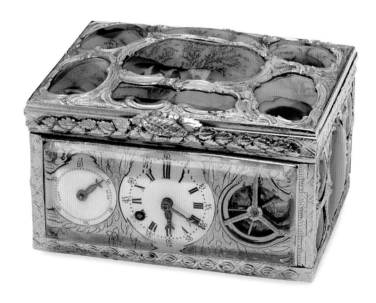

**Freedom box with the
arms of Londonderry**

London, England, 1765
Maker's mark: IC or JC
Gold
w. 10.7cm, d. 7.6cm, h. 4.6cm

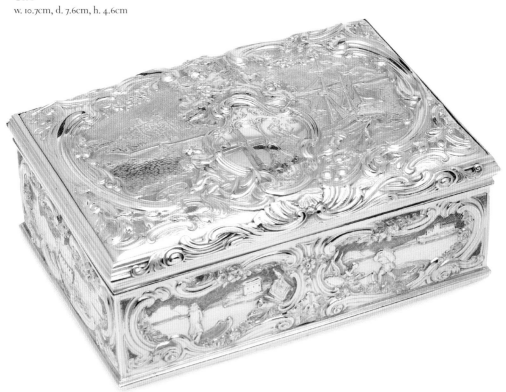

Freedom boxes are often large and therefore more suitable for display rather than as snuff paraphernalia to be carried on one's person. The City of Londonderry presented this box to Robert Alsop, who was given the Freedom of the City of Londonderry in 1747. When he visited Londonderry in 1765, 'a genteel box' was commissioned in London, as the City of Londonderry's archives report.

The box is inscribed on the base: PRESENTED/The 1st Day of Augst. 1765/To Robt. Alsop Esqr./ ALDERMAN of LONDON/and Governour of the Society of the new/Plantation in Ulster in the Realm of Ireland/by the Mayor, Commonalty and Citizens/OF THE/CITY of LONDONDERRY/In Testimony/of their Gratitude & Respect.

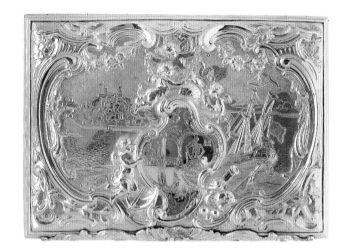

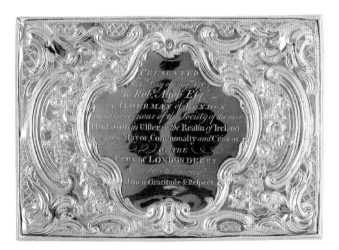

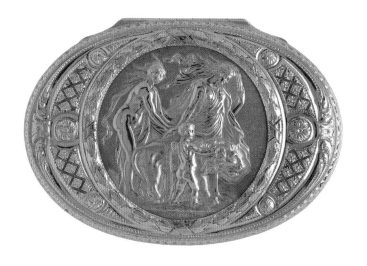

40
Snuffbox with Love overcoming Strength

London, 1774
Box: Paul Barbot (active 1755–1793);
central medallion: George Michael
Moser (1706–1783), signed *G.M.
Moser f* [ecit] *1774*, after a cameo
by Alessandro Cessati (active
1530s–1564)
Varicoloured gold
w. 7cm, d. 4.9cm, h. 2.6cm

The style of this London box
reflects Paris fashions from around
1765, which might have been used as
a model. The central medallion in
contrast is based on a subject matter
already found on antique gems: the
allegory of Strength with her lion is

led away by Venus and Amor. George
Michael Moser, born in Switzerland,
was a gold chaser, enameller and
drawing teacher who became a
prominent figure in the London art
world. He was the first Keeper of
the Royal Academy.

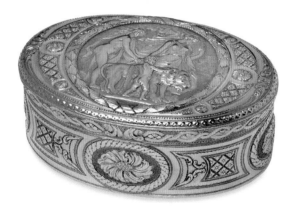

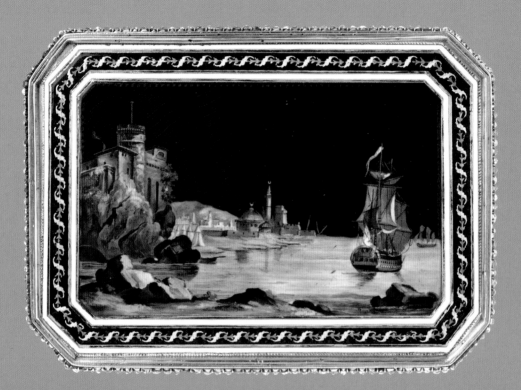

OTHER CENTRES OF PRODUCTION

Watches and gold boxes with fine enamel decoration were a Swiss speciality. They were produced in large numbers in Geneva and offered across Europe and beyond. Swiss makers also ventured to St Petersburg during the reign of Catherine the Great (r.1762–96) and established a strong industry for the production of gold boxes there.

Italian mosaics were an extremely popular means of decoration for gold boxes. Florence hardstone mosaics and minuscule Roman micromosaics rivalled for the attention of Grand Tourists from all over Europe. These panels were highly portable and therefore ideal souvenirs for travellers.

41

Snuffbox in the form of a recumbent lion

Geneva, Switzerland, 1804–09
Moulinié, Bautte & Cie
Gold, enamel and pearls
w. 7.1cm, d. 4.8cm, h. 1cm

Geneva catered for a global market, in particular with colourful, shaped enamelled snuffboxes that were made not as unique commissions but small production series. This playful lion would have appealed to a European customer, but could equally have been made for the Chinese market where lions were in high regard as guardian animals.

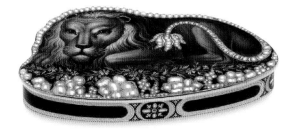

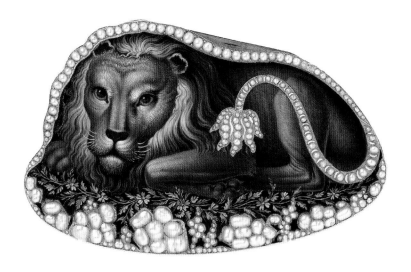

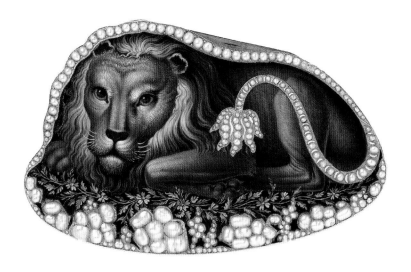

42

Bonbonnière with a portrait of Napoléon Bonaparte
Switzerland and France, *c.*1812
Box: Moulinié, Bautte & Moynier (1793–1821), Geneva, Switzerland; miniature: possibly Jean-Baptiste Isabey (1767–1855), Paris, France
Varicoloured gold, ivory and enamel
diam. 10.3cm, h. 3.3cm

According to tradition, this box was presented by Emperor Napoléon (1769–1821), whose initial N is depicted on the base, to his then mistress Countess Maria Walewska (1786–1817) who had a son by him. It is indeed a present fit for an emperor, even though the traditional provenance has to be treated with caution. The miniature shows Napoléon as younger than he was when the box was made and is inspired by Isabey's 1805 Coronation portrait.

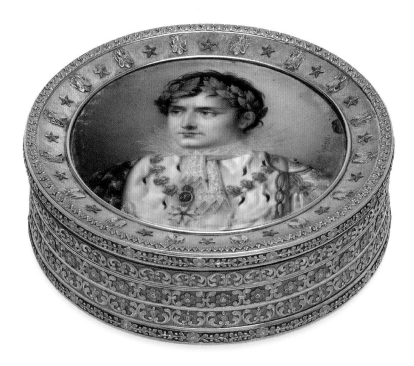

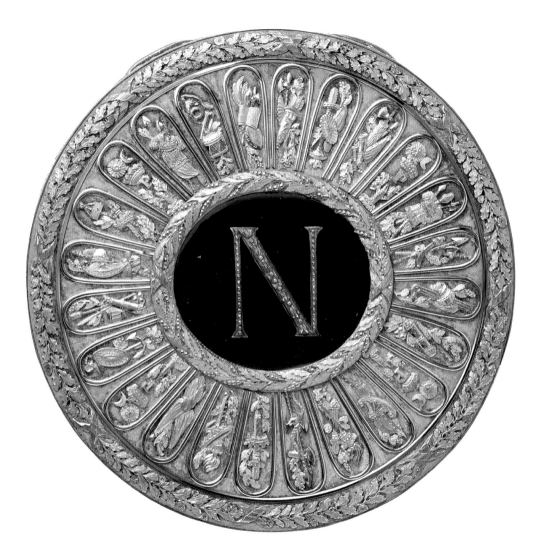

43
Snuffbox with chivalric orders

St Petersburg, Russia, 1762–66
Probably Jean-Pierre Ador
(1724–1789)
Gold and enamel
w. 8.3cm, d. 6cm, h. 4.1cm

The base of this box bears the arms of Baron Nicolaus von Korff (1710–1766), a distinguished soldier in the Russian army. The box is enamelled with the five chivalric orders he received: the Russian Orders of St Andrew (cover) and Alexander Nevsky (right side), the Prussian Order of the Black Eagle (front), the Polish Order of the White Eagle (back) and the Order of St Anne of Holstein (left side). The fine enamel is masterfully even with the gold surface. Its excellent condition might be owed to the protection provided by the original fitted leather case.

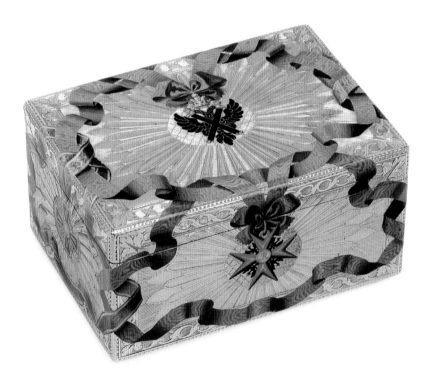

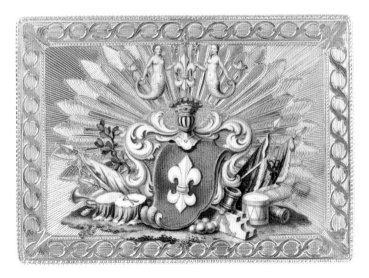

44
Snuffbox as a basket
Probably St Petersburg, Russia, *c.*1775
Enamels attributed to Charles-
Jacques de Mailly (1740–1817)
Gold and enamel
diam. 5.8cm, h. 3.7cm

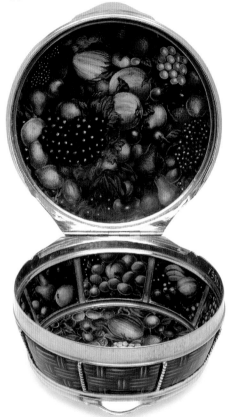

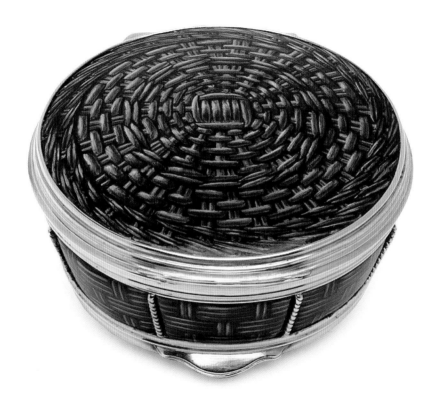

45

Bonbonnière with the equestrian monument for Peter the Great

St Petersburg, Russia, *c.*1782
Francois-Xavier Bouddé
(active from 1769)
Gold and enamel
diam. 7.6cm, h. 3cm

Known today as *The Bronze Horseman* thanks to Alexander Pushkin's nineteenth-century poem, the equestrian statue to Peter the Great (1672–1725) was commissioned in 1766 by his successor Catherine and bears the Russian inscription *To Peter from Catherine II*. The statue, by Etienne-Maurice Falconet (1716–1791), was unveiled on 6 August 1782 in the dramatic ceremony shown opposite.

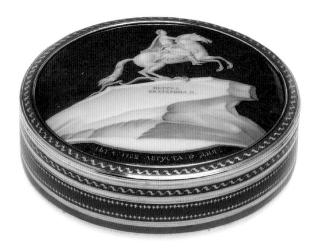

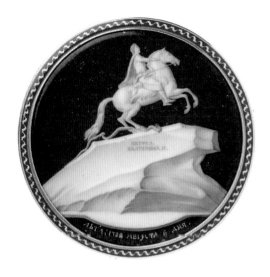

*Unveiling of the
Monument to Peter I*
Russia
After A.P. Davydov, 1782
Two-sided line engraving.
h. 58.5cm, w. 81cm
The State Hermitage
Museum, St. Petersburg
Photograph © The State
Hermitage Museum/photo
Svetlana Suetova

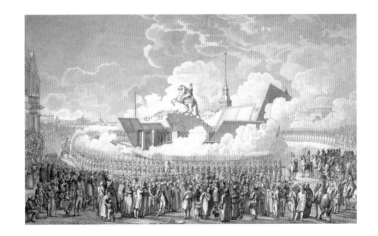

46
**Musical automaton snuffbox
with dancer on a tightrope**
Geneva, Switzerland, *c.*1785
Maker's mark: M & P
Gold, enamel, automaton
mechanism, carillon and glass
w. 7.7cm, d. 6cm, h. 3.4cm

The manufacture of complex
automata and musical movements
was a speciality of the craftsmen
of Geneva. 'Girl-on-a-tightrope'
was a popular late eighteenth-
century model. The keyhole
for winding the automaton is

discreetly fitted above columns to
the left of the figure.

The base, shown opposite,
can be read as a celebration of
music, with musical instruments
arranged as a trophy in a temple-
like space.

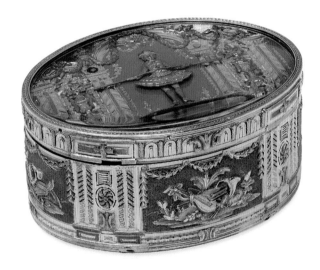

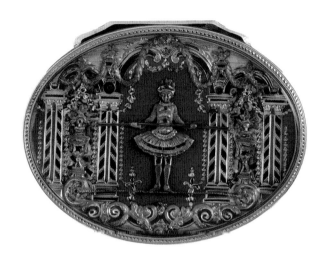

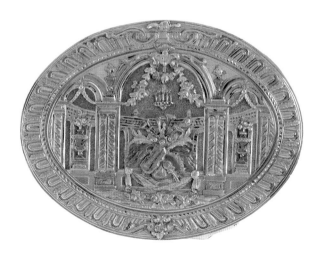

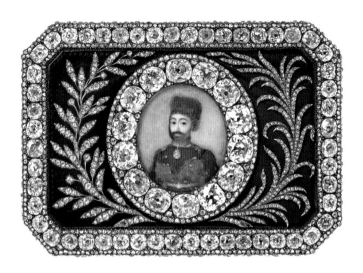

47

Snuffbox with Mahmud II, Sultan of Turkey

Russia and Turkey
Box: probably Pierre-Etienne Théremin (active in St Petersburg 1793–1802), St Petersburg, Russia, 1800; miniature: probably Giovanni Marras (active 1801–30), Constantinople, Turkey, c.1831
Engine-turned gold, enamel, diamonds and glazed miniature
w. 8.2cm, d. 6.2cm, h. 2.7cm

Presentation gifts such as gold boxes were often adapted when the gift was passed on. This box was probably a Russian offering to a Sultan, which originally held a portrait of the Tsar. It was replaced with a portrait of Mahmud II when he in turn used the box as a diplomatic gift. In 1946 the box, then part of the Prussian crown jewels, was found in a church in Bremen, where the jewels were hidden during the Second World War. The base is painted with a view of the Rumeli Hisari fortress on the western shore of the Bosphorus in Istanbul.

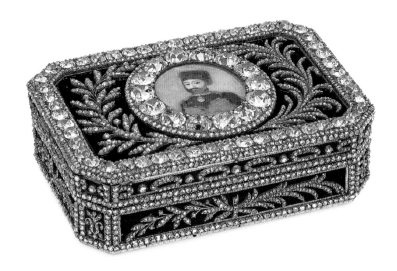

48

Snuffbox with couple and chaperone
Stockholm, Sweden, 1759
Andreas Almgren (active 1746–78)
Gold and enamel
w. 6.5cm, d. 5cm, h. 3.1cm

This box is a Swedish interpretation of techniques and imagery that exemplify the French rococo taste. The hinged back and base shown opposite are testimony to the mastery of its maker: Andreas Almgren specialized in *basse-taille* (low cut) enamel, which is created by chasing gold into relief before fusing translucent enamel onto the surface.

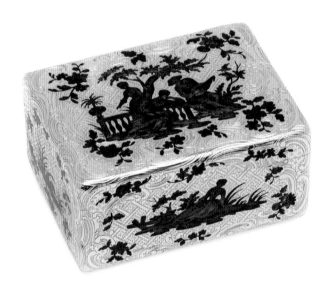

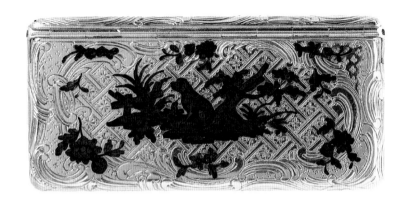

49
Oval snuffbox with musical instruments

Florence, Italy, *c.*1795
Grand Ducal Workshop
(*Opificio delle Pietre Dure*)
Gold, hard and soft stones
w. 9.2cm, d. 6.8cm, h. 3.3cm

The panels decorating this oval snuffbox exemplify the very best of the *pietre dure* technique: carefully selected hardstones are cut and arranged as an intricate picture as detailed and realistic as a painting.

During the late eighteenth century, the Florence Grand Ducal Workshop was at its most innovative and commissioned by rulers across Europe, among them the Grand Dukes of Tuscany.

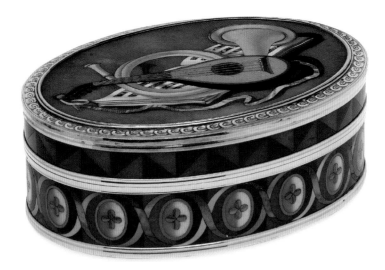

Snuffbox with bear and hound
Probably Rome, Italy, c.1800
Gold and glass micromosaic
w. 8.7cm, d. 5.3cm, h. 2.4cm

This is a fairly early example of a micromosaic with a very limited range of colours and shapes of tesserae. The imagery is inspired by ancient Roman art: bears, dogs and deer were all popular subject matters on Roman floor mosaics and wall paintings. The base panel shows a chariot with a stag and hind just released from the harness, possibly an allusion to the chariot of the goddess Diana.

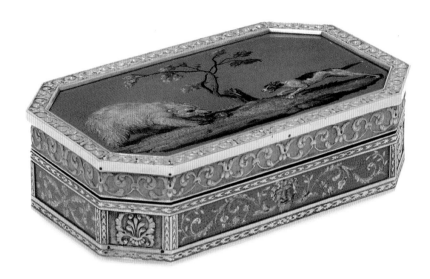

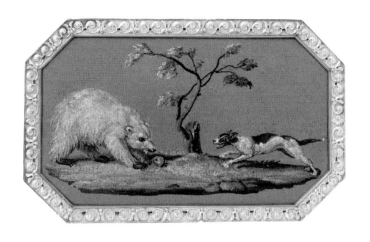

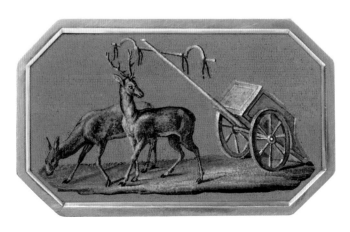

GLOSSARY

Automaton An automaton is a mechanical device constructed to operate automatically, as if by its own motive power. Gold boxes with automata consisting of animated figures or scenes were particularly popular in the late eighteenth century. The manufacture of complex automata often combined with musical movements or watches, was a speciality of the craftsmen of Geneva.

Boîte à portrait The *boîte à portrait* was not a box but a jewelled portrait, usually in enamel, of the monarch, which was presented to the highest ranks of society. The earliest such gift appears in the *Registres des Présents du Roi* in 1667, when Louis XIV offered two *boîtes à portrait* to the Swedish ambassadors, costing a total of 15,480 *livres*.

Bonbonnière Circular boxes without hinges are today described as *bonbonnières*, and were often used to contain sweets or comfits. The word was first introduced around 1770; until that date the term *boîte à bonbons* appears to have been customary.

Cage work is the setting of panels in gold or other materials in a gold frame. In France this practice was officially sanctioned on 4 May 1756, although it is clear that the fashion for boxes mounted in this way was popular earlier. This method of construction was widely adopted elsewhere in Europe.

Chrysoprase From the Greek *chrysos* meaning 'gold', and *prasinon* meaning 'leek'. Chrysoprase is a gemstone variety of chalcedony that contains small quantities of nickel. Its colour varies from apple-green to deep green.

Damascening is the art of inlaying different metals into one another – typically, gold or silver into a darkly oxidized steel background – to produce intricate patterns. The English term comes from a perceived resemblance to the rich tapestry patterns of damask silk.

Enamel An enamel is made by fusing layers of powdered glass coloured by metal oxides to a metal or porcelain base. Enamel on metal is fired at a higher temperature than porcelain, thus producing a harder surface which is more resistant to abrasion. Since each colour changes in the kiln and fuses at a specific temperature, painted enamels require precise planning.

Engine-turning (*guilloché*) is a way of mechanically engraving very fine, intricate, repetitive lines or geometric patterns onto metal and other materials, such as ivory and wood.

Freedom box A freedom box was characteristically English, usually engraved with the arms of the city whose freedom was being bestowed on the recipient of the box. Freedom in this context was largely an honour for extraordinary services to that city or town.

Hard-paste porcelain is a ceramic material, first made in China around the seventh or eighth century. The discovery in Europe of the secret of its manufacture is conventionally credited to Johann Friedrich Böttger of Meissen, Germany in 1708. Today the term chiefly refers to formulations prepared from mixtures of kaolin, feldspar and quartz, which are fired at a very high temperature (around 1400°C).

Lacquer has been produced in Asia since the Neolithic period, and used to protect and decorate a wide variety of objects. The raw material is collected as a milky sap from trees, often mixed with pigments and applied in successive layers, which dry to form a very hard and durable varnish. Lacquer can be embedded with precious materials, or carved. Its finish can be of any sheen level from ultra-matte to high gloss, and it can be further polished as required.

Marchand-mercier By the eighteenth century, the Paris *Corporation des Marchand-Merciers*, originally established in the twelfth century as purveyors of fine fabrics, had become a large body representing retailers of luxury goods, such as paintings, gold boxes, porcelain, furniture, as well as silk and fine fabrics.

Micromosaic The term 'micromosaic' was allegedly coined by Sir Arthur Gilbert to describe pictures made from minuscule pieces of glass, known as tesserae. Inspired by ancient Roman mosaics, the first micromosaics were created in Rome in the eighteenth century. The development of a wide range of colours in opaque glass (*smalti*) enabled mosaicists to produce highly painterly pictures. Most micromosaics are made to a distinct technique, using glass rods, from which tesserae of different sizes and shapes are broken. Micromosaics decorate a range of objects from small, elegant snuffboxes to monumental tabletops.

Pietre dure (hardstones) is made from finely sliced, coloured stones, which are matched to create a picture. The stones can either be inlaid in a partly hollowed stone slab or laid onto a flat stone backing like a jigsaw puzzle. The completed picture is carefully polished. Florence has been the main centre of their production since early modern times.

Portrait miniatures Miniatures were first painted to decorate and illustrate hand-written books. The word 'miniature' comes from the Latin word *miniare*, which means 'to colour with red lead', a practice that was used for the capital letters. Portrait miniatures first appeared in the 1520s, at the French and English courts, and became popular across the rest of Europe. Painted in watercolour, gouache or enamel, they were often used as personal mementos or as jewellery or snuffbox covers.

Soft-paste porcelain is a ceramic material. The porcelain is referred to as 'soft' because its firing temperature is lower (around 1200°C) compared with hard-paste porcelain (around 1400°C).

Turtle shell While the term 'tortoiseshell' is often used historically, and is conventional today, the shell is in fact that of the hawksbill turtle.

Varicoloured gold The relative percentage of the use of pure gold, silver, copper and other chemical elements determines the colour of the alloy used for gold boxes. Pure gold is yellow in colour, but can take on a rose, red or pink shine if the copper or silver content is varied.

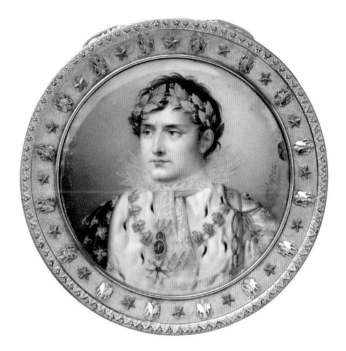

FURTHER READING

Casanova, Giacomo, *The Complete Memoirs of Jacque Casanova de Seingalt*, translated by Arthur Machen, New York: Start Publishing, 2012

Clarke, Julia, 'Swiss Boxes: Myth or Reality?', in: Murdoch, Tessa and Heike Zech (eds), *Going for Gold. The Craftsmanship and Collecting of Gold Boxes*, Brighton-Chicago-Toronto: Sussex Academic Press, 2013, pp. 61–73

Coffin, Sarah and Bodo Hofstetter, *The Gilbert Collection. Portrait Miniatures in Enamel*, London: Philip Wilson Publishers, 2000

Edgcumbe, Richard, *The art of the gold chaser in eighteenth century London*, Oxford: Oxford University Press, 2000

Habsburg-Lothringen, Géza von, *Gold Boxes from the Rosalinde and Arthur Gilbert Collection. Superb Examples of Goldsmith's Art*, Los Angeles: R. & A. Gilbert, 1983

Kugel, Alexis (ed.), *Gold, Jasper and Carnelian. Johann Christian Neuber and the Saxon Court*, London: Paul Holberton Publishing, 2012

Murdoch, Tessa and Heike Zech (eds), *Going for Gold. The Craftsmanship and Collecting of Gold Boxes*, Brighton-Chicago-Toronto: Sussex Academic Press, 2013

Schroder, Timothy (ed.), *The Gilbert Collection at the V&A*, London: V&A Publishing, 2009

Seelig, Lorenz, 'Gold Box Production in Hanau: The Extended Workbench of Frankfurt and its Trade Fair', in: Murdoch, Tessa and Heike Zech (eds), *Going for Gold. The Craftsmanship and Collecting of Gold Boxes*, Brighton-Chicago-Toronto: Sussex Academic Press, 2013, pp. 74–91

Seelig, Lorenz, *Golddosen des 18. Jahrhunderts aus dem Besitz der Fürsten von Thurn und Taxis*, Munich: Hirmer Verlag, 2007

Truman, Charles, *The Wallace Collection Catalogue of Gold Boxes*, London: Paul Holberton Publishing, 2013

Truman, Charles, *The Gilbert Collection of Gold Boxes. Volume Two*, London: Philip Wilson Publishers, 1999

Truman, Charles, *The Gilbert Collection of Gold Boxes*, Los Angeles: Los Angeles County Museum of Art, 1991

Zech, Heike, 'Pleasure and Principle: Collecting Snuff Boxes from 1800 onwards', in: Röbbig München (ed.), *Meissen Snuff Boxes of the Eighteenth Century*, Munich: Hirmer Verlag, 2013, pp. 50–69

Zimmern, Helen (ed.), *The Comedies of Carlo Goldoni*, London: David Stott, 1892

All boxes from The Rosalinde and Arthur Gilbert Collection can be found in *Search the Collections* on the V&A website: www.vam.ac.uk

CONCORDANCE

The following list is an overview of current V&A museum numbers. The numbers in brackets refer to the Gilbert Collection catalogues by Charles Truman (1991 and 1999) as well as the GB (Gold Box) numbers assigned by the Gilberts themselves.

Introduction

1. E.231-1938, purchased with the assistance of The Art Fund and the Goldsmiths' Company
2. 25001.3
3. 436-1892
4. Loan: Gilbert.545:1-2008 (1991, 92: GB 84)
5. 1872-1899
6–7. C.977-1919, bequeathed by Miss Florence Augusta Beare in memory of Arthur Doveton Clarke
8. P.51-1962, bequeathed by C. D. Rotch, 1962
9. Loan: Gilbert.294-2008 (-; MIN 38)
10. Loan: Gilbert.417-2007 (1991, 100; GB 18)
11. E.897.49 to 55-1988, purchased with the assistance of Wartski Limited
12. E.167-1938, purchased with the assistance of The Art Fund and the Goldsmiths' Company
13. E.87 to 92-1938, purchased with the assistance of The Art Fund and the Goldsmiths' Company
14. E.432-1938, purchased with the assistance of The Art Fund and the Goldsmiths' Company
15–16. Loan: Gilbert.360-2008 (1991, 53; GB 43)
17. E.705-1938, purchased with the assistance of The Art Fund and the Goldsmiths' Company
18. 24374:12
19. Waddesdon Manor, The Rothschild Collection (National Trust)

Boxes

1. Loan: Gilbert.314-2008 (1991, 1; GB 149)
2. Loan: Gilbert.315-2008 (1991, 2; GB 117)
3. Loan: Gilbert.321-2008 (1991, 3; GB 107)
4. Loan: Gilbert.411-2008 (1999, 1; GB 201)
5. Loan: Gilbert.326-2008 (1991, 11; GB 46)
6. Loan: Gilbert.320-2008 (1991, 12; GB 22)
7. Loan: Gilbert.328-2008 (1991, 14; GB 145), design: E.897:151–1988
8. Loan: Gilbert.324-2008 (1991, 16; GB 111), design: E.176-1938
9. Loan: Gilbert.382-2008 (1991, 17; GB 61); design: E.897:30-1988
10. Loan: Gilbert.372-2008 (1991, 18; GB 59), comparisons: Loan: Gilbert.375-2008 (1991, 24; GB 97) and Loan: Gilbert.363-2008 (1991, 120; GB 5)
11. Loan: Gilbert.323-2008 (1991, 19; GB 24)
12. Loan: Gilbert.498:1,2-2008 (1991, 21; GB 147)
13. Loan: Gilbert.1052-2008 (1999, 4; GB 226)
14. Loan: Gilbert.371-2008 (1991, 27; GB 161)
15. Loan: Gilbert.361-2008 (1991, 31; GB 83)
16. Loan: Gilbert.452-2008 (1991, 47; GB 77)
17. Loan: Gilbert.403-2008 (1991, 59; GB 101)
18. Loan: Gilbert.402-2008 (1991, 62; GB 50)
19. Loan: Gilbert.404-2008 (1991, 63; GB 37)
20. Loan: Gilbert.416-2008 (1991, 66; GB 122)
21. Loan: Gilbert.492-2008 (1999, 26; GB 170)
22. Loan: Gilbert.501-2008 (1999, 30; GB 215)
23. Loan: Gilbert.396-2008 (1991, 67; GB 143)
24. Loan: Gilbert.327-2008 (1991, 13; GB 33)
25. Loan: Gilbert.413:1, 2-2008 (1991, 73; GB 45)
26. Loan: Gilbert.423-2008 (1991, 72; GB 131) and Loan: Gilbert.414-2008 (1999, 21; GB 167)
27. Loan: Gilbert.412-2008 (1991, 71; GB 120) medal: Loan:Gilbert.515:1 to 3-2008 (1999, 18; GB 164)
28. Loan: Gilbert.503-2008 (1999, 31; GB 172)
29. Loan: Gilbert.333-2008 (1999, 77; GB 87)
30. Loan: Gilbert.346-2008 (1991, 128; GB 153)
31. Loan: Gilbert.352:1-2008 (1991, 80; GB 139) mineralogical cabinet: 192-1878, Victoria and Albert Museum, London, bequeathed by George Mitchell
32. Loan: Gilbert.349:1, 2-2008 (1991, 82; GB 80)
33. Loan: Gilbert.364-2008 (1991, 136; GB 63)
34. Loan: Gilbert.386:1, 2-2008 (1991, 99; GB 8)
35. Loan: Gilbert.389:1, 2-2008 (1999, 37; GB 218)
36. Loan: Gilbert.394-2008 (1991, 101; GB 92); design: E.288-1938
37. Loan: Gilbert.497-2008 (1991, 103; GB 151), comparison: 414:276/1, 2-1885, Victoria and Albert Museum, London, given by Lady Charlotte Schreiber
38. Loan: Gilbert.384-2008 (1991, 105; GB 26)
39. Loan: Gilbert.385-2008 (1991, 104; GB 109)
40. Loan: Gilbert.391-2008 (1991, 107; GB 108)
41. Loan: Gilbert.1047-2008 (1999, 46; GB 195)
42. Loan: Gilbert.456-2008 (1991, 126; GB 32)
43. Loan: Gilbert.344:1, 2-2008 (1991, 129; GB 55)
44. Loan: Gilbert.345-2008 (1991, 130; GB 48)
45. Loan: Gilbert.342:1, 2-2008 (1991, 131; GB 10)
46. Loan: Gilbert.383-2008 (1991, 121; GB 53)
47. Loan: Gilbert.348-2008 (1991, 132; GB 98)
48. Loan:Gilbert.329-2008 (1991, 135; GB 74)
49. Loan:Gilbert.435-2008 (1999, 62; GB 176)
50. Loan:Gilbert.431-2008 (1991, 145; GB 82)

INDEX

ACKNOWLEDGEMENTS

The Trustees of the Gilbert Trust for the Arts, London, and the Gilbert Public Arts Foundation, Los Angeles, very generously made this publication possible. Mélodie Doumy, Assistant Curator of The Rosalinde and Arthur Gilbert Collection, compiled the Glossary and assisted on the project with an excellent eye for detail. Paul Gardner provided stunning photography of the Gilbert Collection boxes. Geoff Barlow, Rachel Malig and Nigel Soper beautifully transformed the original vision for this volume into the actual book. I would also like to thank Tessa Murdoch and Kirstin Kennedy, as well as Vicky Avery, Richard Edgcumbe, Beth McKillop, Rosie Mills, Lorenz Seelig, Charles Truman and Jo Whalley for comments and encouragement.